Digital Cameras & Equipment

FOR

DUMMIES®

PORTABLE EDITION

by Julie Adair King, Serge Timacheff, and David D. Busch

WILEY

Wiley Publishing, Inc.

Digital Cameras & Equipment For Dummies®, Portable Edition

Published by
Wiley Publishing, Inc.
111 River Street
Hoboken, NJ 07030-5774

www.wiley.com

Copyright © 2010 by Wiley Publishing, Inc., Indianapolis, Indiana

Published by Wiley Publishing, Inc., Indianapolis, Indiana

Published simultaneously in Canada

No part of this publication may be reproduced, stored in a retrieval system or transmitted in any form or by any means, electronic, mechanical, photocopying, recording, scanning or otherwise, except as permitted under Sections 107 or 108 of the 1976 United States Copyright Act, without either the prior written permission of the Publisher, or authorization through payment of the appropriate per-copy fee to the Copyright Clearance Center, 222 Rosewood Drive, Danvers, MA 01923, (978) 750-8400, fax (978) 646-8600. Requests to the Publisher for permission should be addressed to the Permissions Department, John Wiley & Sons, Inc., 111 River Street, Hoboken, NJ 07030, (201) 748-6011, fax (201) 748-6008, or online at http://www.wiley.com/go/permissions.

Trademarks: Wiley, the Wiley Publishing logo, For Dummies, the Dummies Man logo, A Reference for the Rest of Us!, The Dummies Way, Dummies Daily, The Fun and Easy Way, Dummies.com, Making Everything Easier, and related trade dress are trademarks or registered trademarks of John Wiley & Sons, Inc. and/or its affiliates in the United States and other countries, and may not be used without written permission. All other trademarks are the property of their respective owners. Wiley Publishing, Inc., is not associated with any product or vendor mentioned in this book.

For general information on our other products and services, please contact our Customer Care Department within the U.S. at 877-762-2974, outside the U.S. at 317-572-3993, or fax 317-572-4002.

For technical support, please visit www.wiley.com/techsupport.

Wiley also publishes its books in a variety of electronic formats. Some content that appears in print may not be available in electronic books.

ISBN: 978-0-470-59147-5

Manufactured in the United States of America

10 9 8 7 6 5 4 3 2 1

WILEY

Table of Contents

. .

Publisher's Acknowledgments

We're proud of this book; please send us your comments at http://dummies. custhelp.com. For other comments, please contact our Customer Care Department within the U.S. at 877-762-2974, outside the U.S. at 317-572-3993, or fax 317-572-4002.

Some of the people who helped bring this book to market include the following:

Acquisitions and Editorial

Project Editor: Kim Darosett
Executive Editor: Steven Hayes
Editorial Manager: Leah Cameron
Editorial Assistant: Amanda Graham

Composition Services

Senior Project Coordinator: Kristie Rees
Layout and Graphics: Christin Swinford
Proofreader: Laura Albert, Susan Hobbs

Publishing and Editorial for Technology Dummies

 Richard Swadley, Vice President and Executive Group Publisher
 Andy Cummings, Vice President and Publisher
 Mary Bednarek, Executive Acquisitions Director
 Mary C. Corder, Editorial Director

Publishing for Consumer Dummies

 Diane Graves Steele, Vice President and Publisher

Composition Services

 Debbie Stailey, Director of Composition Services

Introduction

● ●

*I*t's official: Digital photography is no longer considered a fleeting fad or solely a game for techno-types. Today, everyone from preteens to great-grandmothers is recording their memories with digital cameras, abandoning their old film models to the attic, the basement, or worse.

This growing enthusiasm for digital photography is for good reason, too. The features and quality packed into today's digital cameras are nothing short of astounding. Tiny, fit-in-your pocket cameras are now capable of producing images that, in some cases, surpass those of professional models from five or six years ago — and at prices that were unheard of in years past. Digital SLR models, which accept interchangeable lenses, are now remarkably inexpensive, too, making the step up to semi-pro features much more accessible to enthusiastic shutterbugs.

For many people, though, figuring out how to use all the features offered by today's cameras, let alone how to download, organize, and share digital photos, is an intimidating proposition. First you have to deal with all the traditional photography lingo — *f-stop, shutter speed, depth of field* — and on top of that, you then have to decode a slew of digital buzzwords. Just what *is* a megapixel, anyway? If your professional photographer friend keeps talking about "shooting Raw," does that mean that you should do the same — whatever it is?

In easy-to-understand language, with a dash of humor thrown in to make things more enjoyable, this book spells out what you need to know to choose the right

digital camera for you and how a few accessories can make a dramatic difference in the quality of your photos.

What's in This Book?

This book helps you assess your current digital photography needs and determine the best gear and products to suit your style.

Here's just a little preview of what you can find in each chapter of the book:

- ✔ Chapter 1 provides an overview of the latest and greatest camera features, explaining how they affect your pictures and your photography options.

- ✔ Chapter 2 introduces you to some cool (and useful) camera accessories, picture-storage products, and computer software that enables you to do everything from retouching your pictures to making them look like watercolor paintings.

- ✔ Chapter 3 shows you exactly why digital SLRs can do things that other types of picture-shooters (both film and digital) cannot.

- ✔ Chapter 4 discusses what you can do with interchangeable lenses available for digital SLRs.

- ✔ Chapter 5 describes ten critical steps you should take to protect and maintain your gear — and also offers advice about what to do if disaster strikes.

Icons Used in This Book

Like other books in the *For Dummies* series, this book
uses icons to flag especially important information.
Here's a quick guide to the icons used in this book:

 This icon represents information that you
should commit to memory. Doing so can make
your life easier and less stressful.

 Text marked with this icon breaks technical
gobbledygook down into plain English. In many
cases, you really don't need to know this stuff,
but boy, will you sound impressive if you repeat
it at a party.

 The Tip icon points you to shortcuts that help
you avoid doing more work than necessary.
This icon also highlights ideas for creating
better pictures and working around common
digital photography problems.

 When you see this icon, pay attention — danger
is on the horizon. Read the text next to a
Warning icon to keep yourself out of trouble and
to find out how to fix things if you leaped before
you looked.

What Do I Read First?

For Dummies books are designed so that you can
grasp the content in any chapter without having to
read the chapters that came before it. So if you need
information on a particular topic, you can get in and
out as quickly as possible.

If you're interested in finding out more about digital photography, pick up a copy of *Digital Photography For Dummies,* 6th Edition, by Julie Adair King and Serge Timacheff, or *Digital Photography All-in-One For Dummies,* 4th Edition, by David D. Busch. These are the books that all this information is based on.

Chapter 1

Gearing Up: Does Your Equipment Fit Your Needs?

In This Chapter

▶ Finding the ideal camera for your style of photography

▶ Choosing between point-and-shoot and SLR

▶ Picking enough megapixels

▶ Deciding what camera features you *really* need

▶ Equipping your digital darkroom

▶ Getting the best buys

*P*erhaps you picked up this book because you're finally ready to part with your film camera and join the digital photography ranks. Or, if you're like a lot of people, you might be considering putting your first (or even second) digital camera into mothballs and finding a snazzier model. Either way, the news is all good: Today's digital cameras offer an amazing array of features and top-notch picture quality at prices far below what you would have paid even a year ago.

Now that there are so many high-quality cameras from which to choose, however, it can be tough figuring out which one is best-suited to your needs. To help you make sense of all your options, this chapter provides an overview of the current digital photography scene, discussing what's new and noteworthy and offering some advice on matching camera features to the types of pictures you like to take. In addition, this chapter provides some insights on outfitting the rest of your digital photography studio, describing the computer hardware you need to store, organize, and edit your digital photos.

The Savvy Shopper's Camera Guide

In a fervent battle for your camera-buying dollar, each manufacturer tries to outdo the other by adding some hot new option that promises to make your picture-taking life easier, more fun, or more rewarding. All the new bells and whistles might appeal to your impulse-buying tendencies, but whether you need them depends on how you want to use your camera.

So that you can better understand which options are essential and which ones you can do without, the next sections review the most common (and most critical) features offered by the current crop of digital cameras, along with a few specialty options that may be of interest depending on your photographic interests.

Design options: Point-and-shoot or SLR?

Before digging into specific camera features, it helps to review the two basic design types of digital cameras: compact, point-and-shoot models like the one in Figure 1-1 and digital SLR models like the one in Figure 1-2.

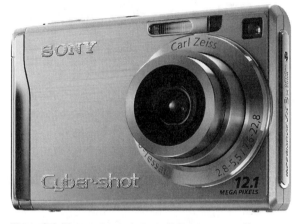

Figure 1-1: Many point-and-shoot digital cameras offer surprising power in a small package.

Sony Corporation of America

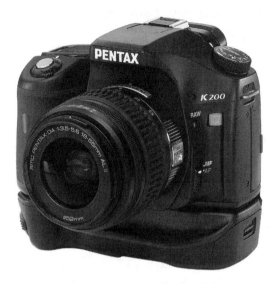

Figure 1-2: A dSLR camera can accept a variety of lenses and offers other higher-end capabilities.

Pentax Imaging Company

Digital SLR models are often called dSLRs. The acronym *SLR,* by the way, means *single-lens reflex* and refers to some internal mechanisms used by this type of camera. Delving deeper into that bit of business isn't critical; the important thing to know is that SLR cameras enable you to swap lenses. You can use a wide-angle lens for your travel photography, for example, and switch to a close-up lens for pictures of flowers and other small subjects (as described in Chapter 4). Point-and-shoot models do not offer this flexibility.

Both types of cameras have their pros and cons:

✔ **dSLRs:** These models offer the greatest degree
of creative control, not only because you can
swap out lenses but also because you get
advanced options for manipulating exposure,
focus, and color not found in most point-and-
shoot models. And dSLRs do tend to be a cut
above in the quality arena because they tend to
have larger image sensors, although many point-
and-shoot models also produce excellent
images. (See the upcoming sidebar "All pixels
are not created equal" for an explanation of how
the size of the image sensor affects picture
quality.)

In addition, dSLRs offer the options that profes-
sionals and serious amateurs demand. They're
made to work well with external flashes, and
they're also able to connect to external lighting
systems (such as studio flashes and modeling
lights). Some dSLRs can shoot up to 10 frames
per second for high-speed, no-lag photos of
action and sports, and many are "ruggedized"
for use in foul weather and other tough environ-
mental conditions.

On the downside, dSLRs are expensive; expect
to pay $400 and up just for the body, plus addi-
tional dollars for lenses. If you already own
lenses, you may be able to use them with a digi-
tal body, however, and lenses for one dSLR
often work with other models from the same
manufacturer. So if you buy an entry-level Nikon
dSLR, for example, and really catch the fever to
go semi-pro or pro, you can use the same lenses
on a higher-end Nikon body.

You should also know that with some dSLRs,
you cannot use the monitor as a viewfinder as
you can with point-and-shoot digitals. This isn't
a major concern for most dSLR photographers,

who prefer framing shots using an old-fashioned viewfinder. But if you want to have the choice, the feature in question is called *Live View* (or something similar). It's implemented in different ways, so experiment to see which design you like best. For a more in-depth look at dSLRs, check out Chapter 3.

dSLRs can be intimidating to novice photographers. If you're new to SLR photography, your best bet is to check out entry-level models, which typically offer you the choice of shooting in automatic mode or manual mode and also offer other ease-of-use features you may not get with a semi-pro, high-end model. Then you can enjoy your camera right away but have the ability to move beyond auto mode when you're ready.

✔ **Point-and-shoot:** These models offer convenience and ease of use, providing autofocus, autoexposure, and auto just-about-everything else. And they're typically less expensive than dSLRs, although some high-end point-and-shoots aren't all that different in price from an entry-level dSLR.

You don't necessarily have to stick with automatic mode just because you go the point-and-shoot route, either. Many point-and-shoot cameras offer just about the same advanced photographic controls as a dSLR, except for the option to use different lenses. Using those advanced controls can be somewhat more complicated on a point-and-shoot, though; on a dSLR, you may be able to access a feature through an external button, but on a point-and-shoot, external controls may be more limited because of the smaller size of the camera body.

Speaking of size, the other obvious decision you need to make is just how much camera bulk you're willing to carry around. Although dSLRs are getting more

compact every year, you're not likely to be able to tuck one in your shirt pocket, as you can with many point-and-shoot models. But you can always do what some pros do: Carry both! Keep a point-and-shoot handy for quick snapshots and pull out your dSLR when you have the time (and inclination) to get more serious.

Picture-quality features

Often overlooked amidst the more glitzy, whiz-bang options touted in camera magazine and television ads are the ones that really should come first in your selection process: the features that affect the quality of the pictures the camera can produce. After all, if a camera doesn't live up to your expectations for its main purpose — producing sharp, clear, colorful photographs — nothing else really matters.

The next three sections discuss three aspects of digital photography that are critical to picture quality: resolution, image noise levels, and file format options. In all three aspects, cameras have really improved over the past few years, so if your current model is a couple of years old, you can likely enjoy an upgrade in picture quality by buying a new model.

Be sure to also check out the later section, "Lens features," for tips on getting a good lens, which is also critical to picture quality whether you shoot film or digital.

Resolution: How many pixels are enough?

Resolution refers to a camera's pixel count. *Pixels* are the tiny points on your camera's image sensor that absorb light and turn it into a digital photo. Today, the pixel count of new cameras is so high that resolution is usually stated in *megapixels,* with 1 megapixel equal to 1 million pixels.

For the purposes of this discussion, all you need to know is that the higher the pixel count, the larger you can print your pictures and expect quality results. As a general rule, you need a minimum of 200 pixels per inch, or *ppi,* to produce an acceptable print; 300 ppi can be even better, depending on the printer.

Just to help you avoid doing the math, the following list shows you how many megapixels you need to produce prints at standard sizes:

- 4 x 6 inches: 1 megapixel
- 5 x 7 inches: 1.5 megapixels
- 8 x 10 inches: 3 megapixels
- 11 x 14 inches: 6 megapixels

All new digital cameras sold today (except those on cell phones) offer at least 3 megapixels; in fact, 6 megapixels is now the common entry point. And many cameras offer 8 to 12 megapixels, with pro models going even higher.

Given that 6 megapixels translate to an 11 x 14-inch print — a size that most of us don't produce on a regular basis — should you pay more for a camera that offers a higher resolution? Again, it depends. Here are a couple of questions to guide you:

- **Are you a serious photographer interested in making large prints on a regular basis?** If so, a monster megapixel count makes sense. See the upcoming "All pixels are not created equal" sidebar, though, for some important news about interpreting pixel count.

- **Do you often crop your photos?** Lots of pixels are also important if you like to crop your photos. As an example, see Figure 1-3. The original image, on the left, has way too much extraneous background, distracting the eye from the

subject; tight cropping resulted in the much better composition shown on the right. Had this photo been taken with a low-resolution camera, the cropped area wouldn't have contained enough pixels to generate a good print at anything but a very small size. But because the image originally contained about 10 megapixels, the cropped area retains the necessary pixels for a good print.

Figure 1-3: A high-resolution camera enables you to crop and enlarge your photos without picture quality loss.

✔ **Do you rarely print photos larger than snapshot size?** If so, a 6- to 8-megapixel camera is plenty, assuming that you don't fall into the regular-cropping category just described. Again, with 6 megapixels, you can output an 11 x 14-inch print if you *don't* crop your photos. So put your money toward a more expensive lens, a faster computer, or image storage hardware instead of more megapixels.

✔ **Do you rarely print photos at *any* size, preferring to share your pictures online?** For onscreen display, pixel count has no effect on picture quality. Pixel count determines only the *size* at which your picture is displayed. For most screen uses, you need very few pixels to display the picture at an appropriate size. Refer to Figure 1-4, for example: The large image shown on this online album page measures only 480 x 320 pixels, and as you can see, it consumes a good chunk of the Web page.

Whether you want to share pictures via e-mail or use them on a blog or Web site, virtually every camera made in the last five years has enough pixels — actually, way *more* than enough. So if you're just shooting pictures for, say, your eBay storefront or the like, you may be able to get a bargain by looking for a discontinued or used camera.

Figure 1-4: Low-resolution images are fine for online sharing; the large photo on this Web page has just 480 x 320 pixels.

If you plan on both printing your photos and sharing them online, concentrate on how many pixels are appropriate for print use, knowing that if you have enough for that purpose, your online needs are more than covered.

All pixels are not created equal

Because digital camera advertisements make a big deal about megapixels, you may be tempted to rush out and simply buy the model that has the highest pixel count. Not so fast. You need to know that more pixels are not necessarily the key to better image quality. The size of the sensor on which the pixels live also matters.

Here's the scoop: Larger, high-end cameras tend to have bigger sensors than pocket-sized point-and-shoot models, for obvious reasons. And as it turns out, cramming more pixels onto a smaller sensor can actually have a detrimental effect on picture quality.

For reasons that aren't really important, if you put the same number of pixels onto a large sensor and a smaller sensor, the camera with the larger sensor typically produces better images. So even though two different cameras — say a subcompact model and a digital SLR — may both boast a 10-megapixel sensor, the dSLR probably has a bigger sensor and therefore provides more quality per pixel.

Of course, pixel count is only one factor contributing to picture quality; other factors, such as lens quality, are also critical.

ISO: How high can you go (without noise)

Through a common digital-camera control, you can adjust the light sensitivity of the image sensor, which is the part of the camera that absorbs light and converts it into a digital photograph. These light-sensitivity settings are stated in *ISO numbers,* such as ISO 100, ISO 200, and so on.

The higher the ISO number, the more sensitive the camera is to light. That means that you can capture an image in dim lighting without flash, use a faster shutter speed, or use a smaller aperture.

However, raising the ISO can also produce *noise,* a defect that gives your image a speckled look. Noise also can be caused by long exposure times, which are sometimes necessary in low-light conditions whether you raise the ISO or not. Finally, low-quality image sensors sometimes create a little bit of noise because of the heat and electrical processes that occur when the camera is used.

Today's cameras are much less noisy than in years past, but noise can still be a problem with high ISO settings and very long exposures. Only a few, high-end cameras can be set to ISOs above 800 without producing noise, for example. Some cameras start to exhibit noise at ISO 400.

Because noise levels vary from camera to camera, this is an important characteristic to study during your camera search. Camera reviews online and in photography magazines regularly include noise tests.

File format options: Can you (should you) go Raw?

File format refers to the type of data file that's used to record the pictures you take. The standard format is JPEG *(jay-pegg),* but some higher-end cameras also

offer a second format called Camera Raw, or just Raw for short.

The short story on Raw is that it offers two benefits that appeal to pro photographers and serious photo enthusiasts:

✔ **Raw files give the photographer more control over the look of a picture.** With JPEG, the camera translates the data captured by the image sensor into a final image, making decisions on such picture characteristics as color saturation, brightness, sharpness, and so on. With Raw, none of this happens. Instead, the Raw file contains "uncooked" picture data, and the photographer then specifies how that data should be converted into a picture. This step is done on the computer, using a software tool known as a Raw converter. (Some cameras also offer a built-in tool for doing the conversion.)

✔ **Raw files deliver the maximum image quality.** During the file-creation process, JPEG files go through a process called *lossy compression,* which reduces file size by eliminating some picture data. And any time picture data is discarded, image quality can be reduced. Raw files, on the other hand, retain all the original picture data to avoid this problem.

All this is not to say that you should bypass cameras that offer only JPEG, however. First, as long as you stick with your camera's highest quality settings, JPEG compression isn't a big deal or even noticeable to most people unless the photo is greatly enlarged. And the compression means that JPEG files are smaller than Raw files, so you can fit more pictures on your camera memory card and on your computer's hard drive.

Perhaps most important, though, consider whether you really want to spend the computer time required to process Raw images — and understand that until you take that step, you can't do much of anything with your photos. You can't share them via e-mail, put them on a Web page, or take them to your local retailer for printing. JPEG files, on the other hand, are ready for use right out of the camera.

All other things being equal, though, a camera that offers both formats beats one that offers only JPEG. You may not be interested in Raw now, but as your skills grow, it may be more appealing to you. And if you're already doing the kind of photography that requires top-notch control and quality, such as for photo contests, galleries, weddings, or other important uses, shooting in Raw is something you'll want to consider.

Lens features

Also important to your long-term satisfaction with a camera are the type and quality of its lens and its related bits and pieces. When comparing cameras, consider these lens factors:

✔ **Optical quality:** Without getting into technical details, the quality of the image that a lens can capture depends on both its material and manufacture. To get an idea of the difference that optical quality can make, just imagine the view that you get when looking through sunglasses that have cheap, plastic lenses versus pristine, real-glass lenses.

Optical quality has improved significantly over the past several years, especially among point-and-shoot cameras. Many models now sport lenses that are made from professional-quality

materials and offer powerful optical zoom capabilities. Of course, you're always going to get the best optics from the types of lenses used by digital SLR cameras — and thankfully, the prices of those models now make them an affordable choice for many people. (See the earlier section, "Design options: Point-and-shoot or SLR?" for more guidance on choosing between the two types of cameras.)

 Unfortunately, it's tough to evaluate a camera's optical quality; it's not something you can judge just by playing around with a few models in the store. So again, your best bet is to study reviews in camera magazines and at online photography sites, where optics are tested according to rigorous technical standards.

✔ **Focal length:** The focal length of a lens, stated in millimeters, determines the angle of view that the camera can capture and the spatial relationship of objects in the frame. Focal length also affects *depth of field,* or the distance over which focus remains sharp.

You can loosely categorize lenses according to the following focal length groups:

- *Wide-angle:* Lenses with short focal lengths — generally, anything under 35mm — are known as *wide-angle lenses.* A wide-angle lens has the visual effect of pushing the subject away from you and making it appear smaller. As a result, you can fit more of the scene into the frame without moving back. Additionally, a wide-angle lens has a large depth of field so that the zone of sharp focus extends a greater distance. All these characteristics make wide-angle lenses ideal for landscape photography.

- *Telephoto:* Lenses with focal lengths longer than about 70mm are called *telephoto* lenses.

These lenses seem to bring the subject closer to you, increase the subject's size in the frame, and produce a short depth of field, so that the subject is sharply focused, but distant objects are blurry. They're great for capturing wildlife and other subjects that don't permit up-close shooting.

- *Normal:* A focal length in the neighborhood of 35mm to 70mm is considered "normal" — that is, somewhere between a wide-angle and telephoto. This focal length produces the angle of view and depth of field that are appropriate for the kinds of snapshots that most people take.

Figure 1-5 offers an illustration of the difference that focal length makes, showing the same scene captured at 42mm and 138mm. Of course, the illustration shows you just two of countless possibilities, and the question of which focal length best captures a scene depends on your creative goals. So you may want to visit a camera store, where you usually can find brochures that illustrate the types of shots you can capture at specific focal lengths. Then just think about the subjects you usually shoot and match the lens focal length to your needs.

42mm 138mm

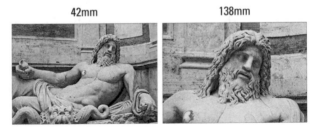

Figure 1-5: A short focal length captures a wide angle of view (left); a long focal length brings the subject closer (right).

✔ **Zoom power:** With a zoom lens, you get a range of focal lengths in one unit. For example, a lens might zoom from 18mm to 55mm. Do note that with a lens that offers a really large focal range — say, 18 to 200 — you tend to see some quality drop-off at certain points in the range. (Here again, camera magazines routinely measure this type of thing.)

When testing a point-and-shoot camera, make sure that the button or knob you use to manipulate the zoom is conveniently positioned and easy to use. On a digital SLR, you zoom by twisting the lens barrel, so this isn't an issue. However, you do want to watch out for so-called *lens creep:* Some SLR zooms have a tendency to slide from one focal length to another, without any input from you, when you tilt the camera.

✔ **Optical versus digital zoom:** For zoom lenses on point-and-shoot cameras, another important factor to note is whether the lens offers an *optical* or *digital* zoom. An *optical zoom* is a true zoom lens and produces the best picture quality. *Digital zoom* is a software feature that simply crops and enlarges your image, just as you might do in a photo-editing program. Because you're then left with fewer original image pixels, the result is typically a reduction in image quality.

You don't have to disregard cameras that have digital zoom; just don't think that it's a benefit to your photography. And if the camera offers both an optical and digital zoom, find out whether you can disable the digital part. Some cameras automatically shift into digital zoom mode when you reach the end of the optical zoom range and don't alert you to that change.

Photo-enthusiast features

Today's digital cameras offer fully automatic every-
thing, so you really can just "point and shoot." But if
you're a photography enthusiast or ready to move
out of automatic mode, look for advanced features
that enable you to take more control over exposure,
color, and other picture characteristics. You can
explore some of these features in the next few
sections.

Advanced exposure options

In order to get creative with exposure, you need a
camera that gives you some control over two critical
settings: aperture (f-stop) and shutter speed. Give
points to cameras that offer the following options:

- ✔ **Aperture-priority autoexposure:** In this mode,
 you can specify the aperture, or f-stop, and the
 camera then selects the shutter speed needed
 to produce a good exposure. Having control
 over aperture is important because the setting
 you use affects *depth of field,* or the distance
 over which objects in the scene appear in sharp
 focus. So if you're shooting a portrait, for exam-
 ple, you can select an aperture that keeps the
 subject sharp while blurring the background.

 This mode typically is represented on camera
 dials by the initials A or Av *(aperture value).*

- ✔ **Shutter-priority autoexposure:** In this mode,
 you select the shutter speed, and the camera
 selects the aperture setting needed to expose
 the picture properly. Because shutter speed
 determines whether moving objects appear
 blurry or "frozen" in place, gaining control over
 this exposure setting is especially important if
 you shoot lots of action pictures.

Shutter-priority autoexposure mode is usually
labeled S or Tv *(time value)* on the camera's
exposure dial.

✔ **Exposure compensation:** Sometimes known as
EV *(exposure value)* compensation, this setting
enables you to tell the camera that you want a
slightly darker or lighter picture than the auto-
exposure system thinks is appropriate. Some
cameras only let you apply this adjustment when
you use shutter-priority or aperture-priority
autoexposure; others make the control available
even when you shoot in fully automatic expo-
sure modes.

✔ **Manual exposure:** In this mode, you can specify
both aperture and shutter speed to precisely
control exposure. Doing so isn't as hard as you
may think by the way, because most cameras
still guide you by displaying a meter that lets
you know whether your picture will be properly
exposed.

These four controls are the most critical for photogra-
phers who want to manipulate exposure, but they're
just the start of the multitude of exposure-related fea-
tures found on today's high-end point-and-shoot and
digital SLR cameras.

Advanced white-balance controls

Digital cameras use a process called *white balancing*
to ensure accurate colors in any light source. In most
cases, automatic white balancing works fine, but
problems can occur when a scene is lit by multiple
light sources — a classroom illuminated by a mix of
window light and fluorescent light, for example. So
having the ability to adjust color manually is helpful.
Just a few feature names to look for:

✔ **Manual white balance** modes enable you to choose a white-balance setting designed for a specific light source, which can solve some color problems.

✔ **White-balance bracketing** records the shot three times, using a slightly different white-balance adjustment for each image.

✔ **White-balance shift (or correction)** makes minor tweaks to the color adjustment that the camera applies for different light sources.

✔ **Custom white-balance presets** enable you to create and store your own white-balance setting. So if you have special photography lights that you use for studio shooting, for example, you can fine-tune the white-balance adjustment to those exact lights.

Advanced flash features

The built-in flash found on most digital cameras offers a convenient source of light but typically produces harsh lighting and strong shadows. For better flash pictures, look for a camera that enables you to attach an external flash, such as the Nikon unit shown on the left in Figure 1-6. Usually, you attach the flash via a *hot shoe,* which looks something like what you see on the right in Figure 1-6. Some cameras also enable you to attach a flash via a cable.

An external flash gives you lots more flash flexibility. If the flash has a rotating head, you can angle the head so that the flash light bounces off the ceiling and then falls softly down on your subject, for example. With some external flashes, you can even position the flash on a stand, off the camera, and then trigger the flash with a remote switch. (See Chapter 2 for more on external flash units.)

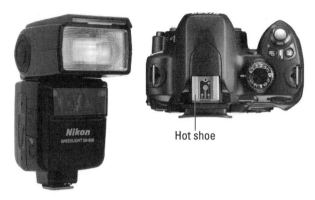

Hot shoe

Figure 1-6: A hot shoe enables you to attach an external flash.

Nikon USA

Other important features for flash photography include the following:

- ✔ **Manual flash control:** For better flash photography, look for exposure modes that enable *you* to decide when the flash fires. On some point-and-shoot models, you can use flash only when the camera thinks additional light is needed. That can be problematic for outdoor photography because many pictures benefit from flash even in bright sunshine.

- ✔ **Flash exposure compensation:** This feature enables you to adjust the power of the flash.

- ✔ **Flash recycle time and power usage:** If the flash on your current camera seems sluggish, you can probably enjoy a significant performance upgrade by investing in a new camera. Flashes on newer cameras also tend to have a faster recycle time — that is, they can recharge and be ready to shoot again more quickly — and use less battery power than in years past.

Viewfinder options

Some cameras lack a traditional viewfinder and instead force you to frame your shots using the LCD monitor. Manufacturers omit the viewfinder either to lower the cost of the camera or to allow a non-traditional camera design. But it can be difficult to go without a viewfinder because you have to hold the camera a few inches away to see the monitor. If your hands aren't that steady, taking a picture without moving the camera can be tricky. When looking through the viewfinder, however, you can brace the camera against your face. Additionally, monitors tend to wash out in bright light, making it hard to see what you're shooting.

Most, but not all, cameras aimed at photo enthusiasts do sport a viewfinder, fortunately. If you decide that a viewfinder is critical, take a look at both traditional viewfinders — sometimes called *optical viewfinders* — and *electronic viewfinders*. Often referred to as an *EVF,* an electronic viewfinder is actually a tiny microdisplay, much like the monitor itself. The electronic viewfinder displays the same image that the camera lens sees, so you can shoot without worrying about *parallax errors,* a phenomenon that can occur with some optical viewfinders. However, some people don't like most electronic viewfinders because the display is less sharp than what you see through an optical viewfinder. Also, you usually can't see anything through the viewfinder until you turn the camera on, which means that you can't set up your shots without using up battery life.

Make-it-easy features

You say you're not interested in becoming the next Annie Liebowitz or Ansel Adams? Relax. You can take great pictures without having to know a thing about

aperture, shutter speed, and all the other advanced stuff discussed in the preceding section.

New digital cameras offer a variety of features designed to make getting great shots easier than ever; just look for the options explored in the next several sections when you shop.

Automatic scene modes

Scene modes are settings that automatically set your camera to shoot a specific type of picture. Most cameras now offer a standard handful of basic scene modes, offering settings designed to shoot action shots, portraits, close-ups, landscapes, and nighttime scenes. But some cameras add many more scene modes, offering settings designed to cope with any number of settings, subjects, and lighting conditions, from shooting underwater to capturing children playing in snow.

 When evaluating cameras, pay attention not just to the number of scene modes, but also to how easily you can access them. Some cameras make you dig through layers of menus to access scene modes, and the more hassle that's required to get to a feature, the less likely you are to use it.

Image stabilization

One common cause of blurry pictures is *camera shake*. That is, the camera moves during the period when the camera's shutter is open and light is hitting the image sensor. The longer the exposure time, the longer you have to hold the camera still to avoid this type of blur. Camera shake is also more of a problem if you shoot with a telephoto lens, especially if it's one of the long, heavy types you can buy for a digital SLR.

You can always avoid camera shake by mounting the camera on a tripod. But a feature called *image stabilization* can enable you to get sharper shots when you need to handhold the camera. The feature may go by different names depending on the manufacturer: *vibration reduction, anti-shake, vibration compensation,* and the like. Whatever the name, the feature is implemented in one of two ways:

- ✔ **Hardware-based stabilization:** With this method, sometimes called *optical image stabilization,* the anti-shake benefit is produced by a mechanism built into the camera or, in the case of some digital SLRs, the lens. This type of image stabilization is considered the best.

 If you're a dSLR buyer, having the mechanism in the camera body means that you enjoy stabilization no matter what lens you attach. However, some experts argue that lens-based stabilization offers better results.

- ✔ **Software-based stabilization:** This type of stabilization, sometimes known as *electronic image stabilization,* or EIS, is applied by the camera's internal operating software rather than a hardware mechanism. It works differently depending on the camera. In some cases, the camera applies some complex correction filters to the image when motion is detected. Other cameras address camera shake by automatically increasing the ISO setting, which makes the camera more sensitive to light. At a higher ISO, you can use a faster shutter speed, which means that the length of time you need to hold the camera still is reduced. Unfortunately, a higher ISO often brings the unwanted side effect of image noise, as discussed earlier in the "Picture-quality features" section.

The payoff you get from image stabilization is another one of those features that is difficult to evaluate from merely playing with a camera for a few minutes in a store. In general, optical stabilization is better than software-based stabilization, but for specifics on how well the cameras you're considering perform in this arena, search out in-depth reviews.

Even the best possible stabilization system can't work miracles; you're still not able to handhold the camera for a very long time before camera shake ruins your picture. Without stabilization, most photographers can hold a camera steady down to a shutter speed of about 1/60 second if they're really good. With image stabilization, you may be able to reduce the shutter speed to 1/30 second — or even 1/15 if you're Cool-Hand Luke.

In-camera Help systems

Many cameras now offer internal Help systems. If you can't remember what a particular button does, for example, you can press a button to see a screen that reminds you, as shown in Figure 1-7. This particular Help screen is from a Nikon camera, but other manufacturers offer similar displays. Built-in help is a great tool for times when you don't want to lug your manual around. Some cameras also offer hints to help you solve exposure problems and other image-capture issues.

Smile/face/blink detection

Camera companies are always looking for snazzy new features to impress you — and just maybe make your photos even better. One of the newest is *face recognition*. This feature automatically detects and focuses on a subject's face as long as you're at a typical portrait-taking distance. This feature is great for taking photos of kids who squirm a lot when getting their picture taken.

?Image quality

Choose file format used to
record pictures.

Figure 1-7: Some cameras offer built-in Help systems.

Taking face recognition one step further, a few com-
panies have announced cameras capable of *smile* and
blink detection! In this mode, the camera tracks a sub-
ject's face and then snaps the photo automatically
when the person's eyes are open and smile is widest.

Of course, these features aren't foolproof; the
camera sometimes misinterprets the scene and
sets focus on the wrong subject. And if you're
capturing a group of people, they're probably
not all going to exhibit those wide smiles and
bright eyes at the exact same moment. So the
best way to ensure that you get a great portrait
is to snap many different images of your subject.
When you review your photos on the monitor,
most cameras enable you to magnify the view so
that you can double-check for open eyes and
great smiles.

Speed features

Among both amateur and pro photographers, one of
the most common complaints about digital cameras
in years past was that they were slow: slow to come

to life when you turned them on, slow to respond when you pressed the shutter button, and slow to finish recording one image so that you could capture another. This sluggish behavior made capturing action shots extremely difficult.

Well, camera manufacturers heard the complaints and responded with a variety of technical changes that greatly reduced the problem. So if you've been frustrated with this aspect of your current camera, a new model will likely ease the pain. Most cameras now can keep up with the most demanding rapid-fire shooter, although again, you should read reviews carefully because cameras vary in this regard.

Along with faster start-up and image-recording times, many new cameras also offer some, if not all, of the following features to make speed shooting even easier:

- ✔ **Burst mode:** In this mode, sometimes called *continuous capture,* you can record multiple photos with one press of the shutter button, reducing the time needed to record a series of pictures. Typically, you can capture several frames per second — the exact number varies from camera to camera. In Figure 1-8, for example, a burst speed of three frames per second captured five stages of the golfer's swing.

- ✔ **Shutter-priority autoexposure or manual exposure:** In both exposure modes, you can control the shutter speed, which is critical to determining whether a moving subject appears blurry. If you shoot a lot of action shots, this kind of shutter control is highly recommended.

- ✔ **Sports mode:** This mode enables even photography novices to capture action without having to learn all the ins and outs of shutter speed, ISO, and other exposure intricacies. Just dial in the Sports setting, and the camera automatically adjusts all the necessary controls to best capture a moving target.

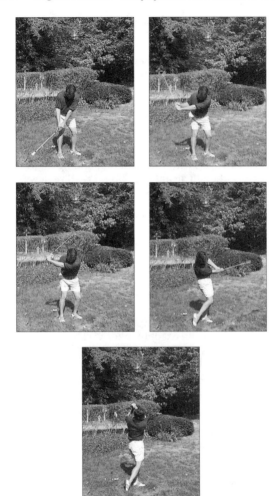

Figure 1-8: Burst mode enables you to shoot a moving target. Here, a capture setting of three frames per second broke a golfer's swing into five stages.

✔ **Dynamic or continuous autofocus:** This auto-focus mode, which may go by different names depending on the model, adjusts focus as needed right up to the time you take the shot to keep moving subjects in focus.

✔ **Compatibility with high-speed memory cards:** Camera memory cards — the little removable cards that store your pictures — are rated in terms of how fast they can read and write data. With a faster card, the camera needs less time to store the image data after you shoot the picture. Although older cameras often can't take advantage of the speed increases, many newer models are designed to work with even the fastest cards. (See Chapter 2 for more on memory cards.)

Other fun (and practical) features

Describing all the features found on the latest digital cameras is nigh on impossible; it seems that every day, some new camera option is announced. But the following list introduces you to some of the most common additional features that may be of interest to you. These options fall into the category of not necessary but nice to have — sort of like an extra cup holder in your car or a bonus track on a CD:

✔ **In-camera editing tools:** Many cameras offer built-in retouching filters that can fix minor picture flaws, such as red-eye or exposure problems. Some cameras that can capture pictures in the Camera Raw format even offer an in-camera converter that translates your Raw file into the standard JPEG format. (See the earlier section related to file formats for more about this issue.) These tools are especially helpful for times when you need to print or share a photo before you can get to your computer to fix the image in your photo software.

✔ **Adjustable LCD monitors:** Most newer cameras feature larger LCD screens than the somewhat smallish versions offered in first-generation models. In fact, some monitors are nearly as large as the back of the camera. But some cameras, such as the Canon model shown in Figure 1-9, take the monitor design a step further, featuring fold-out screens that can be rotated to a variety of angles. This adjustable type of monitor enables you to shoot at nearly any angle while still being able to see the monitor.

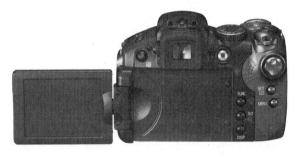

Figure 1-9: Some monitors can be adjusted to different viewing angles.

Canon U.S.A. Inc.

✔ **Video capture:** Some point-and-shoot cameras can record short digital movie clips. Although not intended as a replacement for a real camcorder, this feature can be a fun way to capture a little "live action" along with your still photos.

✔ **Print and e-mail functions:** Many cameras enable you to create an e-mail-sized copy of a high-resolution image. (See the earlier section related to resolution to find out why you don't want to simply send that high-res image through cyberspace.) And some cameras offer a feature

called PictBridge, which enables you to connect
your camera directly to your printer, so you can
print your photos without ever downloading to
your computer. (The printer also must offer
PictBridge capabilities.) This feature is great for
printing pictures at birthday parties, conven-
tions, and the like.

✔ **Video-out capabilities:** If the camera has a
video-out port, you can connect the camera to
a television and view your pictures on the TV
screen, as shown in Figure 1-10. This feature is a
great way to share photos with the entire family
or co-workers.

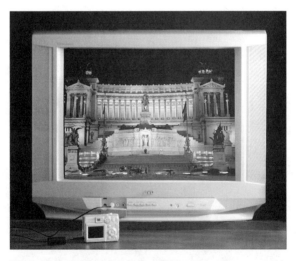

Figure 1-10: To view pictures on a TV, you need a camera that
has a video-out port.

✔ **Wireless image transfer:** There's a lot in the air today. It seems like everything is wireless, from the WiFi connection at your local coffee shop to everyone walking around looking like aliens with their Bluetooth cell phone earpieces. And, of course, digital photography is no exception. Some high-end dSLRs support optional wireless file transmitters that connect using networking technology so that photographers can instantly send images from the camera to a computer. This capability is useful, for example, for photo-journalists who need to get images from important news or sports events posted immediately on the Web.

For consumers, some cameras can use a new type of wireless memory card, the Eye-Fi SD card, shown in Figure 1-11. This card gives you the ability to wirelessly transmit images to your home computer using a WiFi connection. Chapter 2 talks more about buying and using memory cards.

Figure 1-11: The Eye-Fi SD card combines a 2GB memory card with a wireless file transmitter.

Serge Timacheff

So . . . is it time to upgrade?

Summing up all the details in the preceding sections, the answer to the question posed by the headline is, well, maybe. Assuming that your camera is a couple of years old, you should definitely look at a new model if any of the following statements apply:

- ✔ You're not happy with the quality of your photos, especially when you print them larger than snapshot size.

- ✔ You have trouble capturing action shots because your camera is a slow performer.

- ✔ Your pictures appear noisy (speckly) when you shoot in dim lighting.

- ✔ You're a serious photographer (or want to be) and your camera doesn't offer any exposure controls, Raw image capture, a flash hot shoe, or other advanced features.

- ✔ You have trouble viewing your pictures on the camera monitor because it's too small and difficult to see in bright light.

- ✔ Your pictures are often ruined by camera shake (which causes blurry pictures), and you could benefit from image stabilization.

Of course, some cameras address these issues better than others, so again, be sure that you read reviews on any new model you consider. Also consult with the salespeople at your local camera store, who can point you toward cameras that best solve the picture-taking problems you're experiencing.

Equipping Your Digital Darkroom

In addition to deciding on whether your camera meets your needs, you also need to ponder whether

the core component of your digital darkroom — the computer itself — is suitable for the types of projects you like to do.

Here's a quick overview of the characteristics of a system that will serve you well in the digital photography arena:

✔ **System components:** Just as the cost of digital cameras has dropped dramatically over the past few years, new computer systems, too, offer you a lot more power for your money than in the past. But at the same time, image-editing software has become more sophisticated and demanding of your system's resources. Plus, digital cameras are producing larger image files, which not only require more storage space but also require more system resources to process in your photo editor.

Long story short, having plenty of system memory (RAM), a large hard drive, a capable graphics card, and a relatively fast processor will make your digital photography work much easier and can even pay for itself in time saved during image processing.

✔ **Operating system:** The computer's operating system — OS, in geek terminology — also can make a difference. You can run many photography programs on older versions of Windows or the Mac OS, but the newer versions are optimized to work better with images. For example, Mac Leopard's "Quick Look" and Windows Vista's Explorer both provide much-improved ways to search for and review images than previous editions of either operating system.

✔ **USB connectivity:** New digital cameras, printers, memory-card readers, and other digital imaging devices connect to computers through a technology known as USB (Universal Serial

Bus). If your computer is old enough that it doesn't yet support the latest version of this technology, USB 2.0, you may want to upgrade to that standard. (You can buy a USB 2.0 card and install it in your computer; your local computer expert can show you how.) This feature determines in part how fast you can transfer images from the camera to the computer or from a memory-card reader to the computer, and you can enjoy faster performance by moving from USB 1.0 to 2.0.

✔ **Monitor:** A monitor is another important component of your digital darkroom. It used to be that those big, bulky TV-like monitors (CRT, or *cathode-ray tube,* monitors, to be specific) produced the best-quality computer displays and that LCD monitors were considered amateurish and gimmicky. Not so today: LCD displays have overtaken the market as the standard, and the images they produce are nothing less than stunning. You can get ultra-high resolution monitors (that even support HDTV, for heaven's sake) at a remarkably affordable price that will make your photos look like they're alive in your studio.

One tip, however: Especially if you're doing color-critical imaging work, be sure to shop carefully to make sure that the LCD performs well for this type of use — some are better than others, as with any product. Also, if you still have a CRT monitor, and it's working well for you, there's no need to run out and replace it with an LCD. You may discover that it provides a better display than many new, low-priced LCDs, in fact. Of course, it doesn't look nearly as cool on your desk, but . . .

Mind you, this isn't to suggest that you must go out and buy a brand-new computer and all the trimmings. If you use a medium-resolution camera that doesn't produce huge picture files, and you stick with

consumer-level photo software, such as Adobe Photoshop Elements, you may be just fine with a computer that's a few years old or a middle-of-the-line new system. If you do work with an older system, though, you may find it beneficial to treat yourself to some new hardware.

Sources for More Shopping Guidance

If you read this chapter, you should have a solid understanding of the features you do and don't want in your digital camera as well as in the other components of your digital darkroom. But you need to do some more in-depth research so that you can find out the details on specific makes and models.

First, look in digital photography magazines as well as in traditional photography magazines (such as _Shutterbug_) for reviews on individual digital cameras and peripherals. Some of the reviews may be too high-tech for your taste or complete understanding, but if you first digest the information in this chapter, you can get the gist of things.

If you have Internet access, you can also find good information on several Web sites dedicated to digital photography.

One final bit of buying advice: As you would with any major investment, find out about the camera's warranty and the return policy of the store where you plan to buy. Many retailers charge a _restocking fee,_ which means that unless the camera is defective, you're charged a fee for the privilege of returning or exchanging the camera. Some sellers charge restocking fees of 10 to 20 percent of the camera's price.

Chapter 2

Extra Goodies for Extra Fun

. .

In This Chapter

▶ Buying and using camera memory cards

▶ Storing all your picture files

▶ Choosing photo software

▶ Protecting your camera investment

▶ Looking at tripods and flash units

▶ Becoming a gadgets freak

. .

Do you remember your first Barbie doll or — if you're a guy who refuses to admit playing with a girl's toy — your first G.I. Joe? In and of themselves, the dolls were entertaining enough, especially if the adult who ruled your household didn't get too upset when you shaved Barbie's head and took G.I. Joe for a spin in the garbage disposal. But Barbie and Joe were even more fun if you could talk someone into buying some of the accessories. With a few changes of clothing, a plastic convertible or tank, and loyal doll friends like Midge and Ken, Dollworld was a much more interesting place.

Similarly, you can enhance your digital photography experience by adding a few hardware and software accessories. Digital camera accessories don't bring quite the same rush as a Barbie penthouse or a G.I. Joe surface-to-air missile, but they greatly expand your creative options and make some aspects of digital photography easier.

This chapter introduces you to some of the best digital photography accessories, from portable hard drives that let you store images on the road to new-fangled tripods that can grip almost anything.

 All the prices quoted in this chapter and elsewhere are what you can expect to pay in retail or online stores. Because prices for many digital imaging products seem to drop daily, you may be able to get even more for your money by the time you're finished reading this book.

Buying and Using Memory Cards

Instead of recording images on film, digital cameras use removable *memory cards.* Some cameras ship with a starter card, but it's typically a small-capacity card that can hold very few pictures. So it's a safe prediction: You'll need to buy a memory card, or two, or more.

When you shop for memory cards, you encounter many different card types. But the decision about which type you need is pretty much made for you because most cameras, with the exception of a few high-end models, can use only one kind. So check your camera manual to find out which of the following card types it accepts:

- ✔ **SD (Secure Digital):** The most popular card type because of their small size, reliability, and high capacity, these cards are supported by a wide variety of digital cameras.

- ✔ **SDHC (Secure Digital High Capacity):** These cards look just like SD cards, but they use a new technology that allows greater storage capacity than SD cards.

 Although you can use SD cards in most devices that support SDHC, the reverse isn't always true. Note, too, that if you want to download images to your computer using a memory-card reader, the reader also must be compatible with SDHC, not just SD.

- ✔ **MiniSD:** About half the size of an SD card, MiniSD cards are often used in very small digital cameras. If your card reader doesn't support MiniSD directly, you can get a special MiniSD adapter that lets you use them in your SD card slot.

- ✔ **CompactFlash:** These cards, which are physically larger and square-shaped, are very popular in larger digital cameras. They support a wide variety of storage capacities ranging from small to very large; some CompactFlash cards can store more than 16GB (gigabytes) of picture data.

- ✔ **xD-Picture Card:** Designed by Fujifilm and Olympus, these cards are smaller than a postage stamp but hold a remarkable amount of photos.

- ✔ **Sony Memory Stick:** About the size of a stick of chewing gum, these cards are used in some Sony cameras and other Sony devices.

After finding out what card type you need, the next decision to make is what card capacity you need. The

good news is that most types of removable camera memory are very affordable — unlike gasoline, memory cards have dropped dramatically in price over the past couple of years, so you can afford to carry around a lot of picture-storage capacity. Keep in mind that the more memory you can carry with you, the less often you need to stop shooting to download pictures to your computer.

How many pictures can a memory card hold? The size of a picture file depends on several factors, including what resolution and file format you use when you shoot the photo. Your camera manual should provide a table that lists the specific file sizes of pictures taken at each of the resolution and format settings the camera offers. But Table 2-1 gives you a general idea of approximately how many pictures can fit in various amounts of memory. The table assumes that the picture is taken using the JPEG file format with a minor amount of compression — a setting that translates to good picture quality. If you shoot in the Camera Raw format, your files are substantially larger. On the other hand, if you use a lower-quality JPEG setting, file sizes are much smaller.

Table 2-1 How Many Pictures Can a Memory Card Hold?

Resolution	256MB	512MB	1GB	2GB	4GB
2 megapixels	296	592	1184	2368	4736
3 megapixels	216	432	864	1728	3456
4 megapixels	132	264	528	1056	2112
5 megapixels	100	200	400	800	1600
6 megapixels	84	168	336	672	1344
7 megapixels	76	152	304	608	1216
8 megapixels	64	128	256	512	1024

Approximate storage capacity based on high-quality JPEG images (minimum compression).

Memory shopping tips

Here are a few other pointers on buying camera memory:

- ✔ Remember, most cameras can use only one type of memory, so check your manual for specifics. You don't have to buy any particular brand, though; it's the card type that matters — CompactFlash, Memory Stick, and so on.

- ✔ Also, check your camera manual to find out the maximum capacity card it accepts. Some older cameras can't use the new, high capacity cards.

- ✔ Memory cards come in a variety of "speeds." No, this doesn't mean how fast you can stick them into the camera and shoot (sorry, Quick Draw). Rather, it refers to how fast your images can be recorded on them and moved from them to the computer. This speed is specified on the card with a number and an "x" sign: 66x, 90x, 133x, and so on, with a higher number indicating a faster card. Card speed is especially important for cameras that can shoot lots of photos in quick succession; faster cards mean that you can keep shooting without any pauses. Of course, speed equates to cost: The faster the card, the more expensive it is.

 Before you buy, check to make sure that your camera is engineered to take advantage of the higher-speed cards (most point-and-shoot models are not). Also, understand that you probably won't notice a difference unless you're shooting at high resolutions — say, 5 megapixels or more. Finally, note that when it comes to how fast you can download images, the speed of the card isn't the only factor; the capabilities of the card reader and your computer come into play as well.

✔ As with other commodities, you pay less per megabyte when you buy "in bulk." A 2GB card costs less per megabyte than a 512MB card, for example.

Care and feeding of memory cards

To protect your memory cards — as well as the images they hold — pay attention to the following care and maintenance tips:

✔ When you insert a card into your camera for the first time, you may need to format the card so that it's prepared to accept your digital images. Look in your camera manual for information on how to do this formatting.

Be careful *not* to format a card that already contains pictures, however. Formatting erases all the data on a card.

✔ Never remove the card while the camera is still recording or accessing the data on the card. (Most cameras display a little light or indicator to let you know when the card is in use.)

✔ Don't shut off the camera while it's accessing the card (although most cameras will prevent themselves from turning off if this is occurring).

✔ Avoid touching the contact areas of the card. On an SD card, for example, the little gold strips are the no-touch zone, as shown in Figure 2-1. On a CompactFlash card, make sure that the little holes on the edge of the card aren't obstructed with dirt or anything else. (Most cards ship with a little flyer that alerts you to the sensitive spots on a card.)

✔ Some types of cards, such as Secure Digital cards, have a locking feature. By sliding a little switch on the card, you can prevent access to

the card, which means that no files can be erased or added. Figure 2-1 gives you a look at the lock.

✔ If your card gets dirty, wipe it clean with a soft, dry cloth. Dirt and grime can affect the performance of memory cards.

✔ Try not to expose memory cards to excessive heat or cold, humidity, static electricity, and strong electrical noise. You don't need to be overly paranoid, but use some common sense. Some "extreme" cards are available, made primarily for working in very high/low temperatures.

✔ Ignore rumors about airport security scanners destroying data on memory cards. Although scanners can damage film, they do no harm to digital media, whether in checked or carry-on bags.

Figure 2-1: SD cards have a lock switch that prevents access to the card data.

✔ To keep your cards safe while not in use, store
them in their original plastic sleeves or boxes.
Or, for a handy way to store and carry multiple
cards, invest in a memory card wallet. The
Tenba version shown in Figure 2-2 has compart-
ments for batteries as well as memory cards
(www.tenba.com).

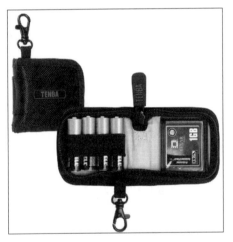

Figure 2-2: A memory-card wallet provides safe storage for
spare cards.

TENBA Gear

Storing Your Picture Files

A hot topic in the world of professional photography
is *digital asset management,* which is simply a fancy
term referring to the storing and cataloging of digital
picture files. (If you want to be über-hip, you can refer
to it as DAM — and, yes, it's pronounced just like the
four-letter word you used to get in trouble for saying

as a kid.) Professional digital photographers accumulate huge collections of images and are always striving for better ways to save and inventory their assets.

Your image collection may not be as large as that of a professional photographer's, but at some point, you, too, need to think about where to keep all those photos you take. You may be at that point now if you shoot high-resolution pictures and your computer's hard drive — the thing that stores all your data files — is already cramped for space.

The next several sections discuss the three most common strategies for expanding your digital closet space.

Adding more hard-drive space

If the existing hard drive on your computer is bursting at the seams, you can add a second (or third or fourth) drive for relatively little money. And you don't even have to crack open the computer's case to install an internal drive; plenty of companies make external drives that attach via a USB (Universal Serial Bus) connection or, in some cases, via a second type of connection called FireWire.

Nor do you have to give up much desk space to add storage; many drives are no larger than the size of a wallet. For example, Figure 2-3 shows the My Passport drive from Western Digital (www.westerndigital.com), which holds 250GB of data and retails for about $130. The great thing about this type of drive is that it's designed to be portable, so you can pack it in your camera bag when you travel as well as use it at home. (This unit does draw its power from the computer's USB connection, so you need to carry your laptop or have access to another computer at your destination, however.)

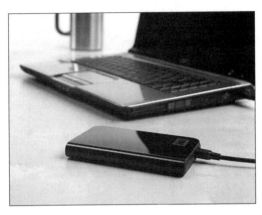

Figure 2-3: External drives such as the Western Digital My Passport can hold a lot of data in a unit about the size of your wallet.

Although adding a second hard drive may temporarily solve your picture storage concerns, you should not rely on this option for long-term, archival storage. Hard drives are mechanical devices, and as such, they can fail on occasion. And if your hard drive goes bad, all your picture files are likely to be lost. Keeping your pictures on a hard drive for quick and convenient access is fine, but always make backup copies on archival media. This same warning applies, by the way, to Zip drives, portable thumb drives, and flash memory keys.

At present, the two best options for archival storage are CDs and DVDs, discussed next.

CD storage

For the safest long-term storage of your image files, regularly back up the images stored on your computer's hard drive (or other storage device) to a CD-ROM. If your computer is new, you likely have a built-in CD *burner* (that's the techy way to say CD recorder). If not, you can add an external model to your system for under $100.

You do need to follow a couple of precautions to get the longest life span from your CDs:

✔ Buy disks labeled CD-R, not CD-RW. The first type can't be erased, whereas data on CD-RW discs can be overwritten. In addition, some manufacturers say that their archival-grade CD-Rs have life expectancies of as much as 100 years, while CD-RWs are said to survive about 30 years. Those claims are the subject of some pretty hot debate right now — and if you ask around, you're sure to hear horror stories of CDs going bad. Whether the problem stems from the CD itself or mishandling by the user is the question.

✔ Look for blank CDs that have a gold coating and are advertised as archival quality. You pay more for the quality; archival discs cost about $1.50 each, versus $1 or less for the non-archival versions. But the idea is to make sure your pictures last, right?

✔ Don't use a permanent marker to write labels directly on the discs. The ink can damage the disc and the data stored on it.

✔ Just to be extra safe, burn two copies of CDs that contain your most precious photographic memories. That way, if one disc gets scratched or lost, you have a backup to your backup.

Burning your own CDs is much easier than in years past, thanks to software that walks you through the process. Still, if you're not comfortable with the job, you may prefer to let the professionals do your CD burning. Most retail photo labs and even superstore photo departments (such as Costco and Wal-mart) can burn CDs from camera memory cards.

A bigger drawback to the CD solution — and one not so easily overcome — is that CDs can hold only about 650MB of data. If you're shooting with a high-resolution camera, you can fill up a CD in no time. So for non-critical images, you may want to back up your files to DVD instead, as explained next.

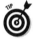 For the ultimate in archiving safety, always print your best pictures, too. That way, if something does go wrong with the digital file, you can scan the print and create a new digital copy. You can make prints easily and cheaply at any retail lab if you don't care to do it yourself.

DVD storage

Close cousins to the CD burner, DVD burners enable you to record your photos onto a DVD (digital video disc). What's the difference between CDs and DVDs? Capacity, for one. A standard single-layer DVD stores 4.7GB of data, while a CD holds about 650MB.

That's the good news about DVDs. But this technology has some complications, too:

> ✔ Blank DVDs currently aren't available with the archival gold coating that's offered on some CDs. So the longevity of DVDs may not equal that of those archival CDs.

✔ Although most computers now have a DVD drive, not all systems have a DVD burner. If the DVD drive on your computer just says DVD-ROM, it can read a DVD disc that has data or a movie on it. If it says DVD-R/RW, it can actually *record* onto a DVD disc.

✔ If you do have a DVD burner, check its manual to find out what flavor of blank DVDs to buy. Several DVD formats exist: DVD+R, DVD-R, single layer, dual-layer, and so on.

✔ Although many DVD drives can use all the various types of DVDs, not all can. That means that accessing your DVD files on computers other than the one you used to burn the disc isn't always possible.

✔ As with CD archiving, don't use the DVDs that have the RW distinction; data on those discs can be overwritten or erased.

On-the-Go Storage and Viewing

Even if you carry several large-capacity memory cards, you can fill them up quickly if you're using a high-resolution camera or shooting Raw files. Simply buying more cards as you go may sound logical, but whenever possible, you really should download as soon as you fill a card. Memory cards have been known to fail and are easy to lose. And your camera could be lost or stolen, with all your photos in it. You might get a new camera, but you won't have those photographs any more.

For times when you don't want to travel with a computer, you can pack smaller, more portable storage options in your camera bag. Here are just a few of the alternatives:

✔ **Portable hard drives:** Several companies make portable storage units that can function independently on the road and then serve as an external drive and card reader when connected to your computer at home. Figure 2-4 shows one option, Digital Foci's Photo Safe II (www.digital foci.com). An 80GB model will set you back about $140.

Figure 2-4: Digital Foci's Photo Safe II lets you securely store thousands of images on the road without a computer.

Digital Foci, Inc.

✔ **Drive and viewer combos:** Some portable drives have screens on which you can review your pictures. This feature is especially great for photographers who work with clients in the

field; you can show your work this way rather than pass your camera around after every shot. Figure 2-5 shows one such product, the Epson P-5000, which offers 80GB of storage space and can be had for about $600. (Digital Foci also offers some drive/viewer products.)

Figure 2-5: This portable storage unit from Epson has a large screen for viewing your pictures.

Seiko Epson Corp.

✔ **Portable media players (PMPs):** Among the most cool and useful accessories for digital photography and travel in general, these snazzy gadgets come from several different companies in a variety of designs and with various features, but they almost always include the ability to store and play all kinds of digital media along with a bunch of other functions. One product in this category is the Creative Zen Vision W (www.creative.com), shown in Figure 2-6. This particular unit not only provides the features listed earlier, but also has a radio, a voice memo recorder, and Microsoft Outlook contact and organizer display capabilities. A 60GB version of the product sells for about $400.

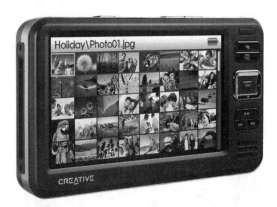

Figure 2-6: PMPs store images as well as MP3s and videos for a great travel tool and photo backup.

Creative Technology LTD.

As you might expect, prices for all these devices vary greatly, depending on the storage capacity, the size of the screen, and other features. But keep in mind that when you get home from your travels, you usually can attach these on-the-go devices to a computer via a USB cable and use them as another desktop or laptop storage drive.

Do be sure that whatever device you buy either offers a card slot for the type of memory card your camera uses (or that you can buy an adapter to make your card fit the slot) or can be connected directly to your computer via USB cable for image transfer. Also, note that some viewers can't display images captured in the Camera Raw format, so if you prefer that format, read the fine print. (Chapter 1 explains Camera Raw.)

Protecting Your Camera

Perhaps the most important camera accessory you can buy is a camera bag, case, or other product that will keep your investment dry, cushioned, and easy to transport. Thousands of inventive gadgets and devices are available that not only protect your gear but also let you impress your family, friends, neighbors, and anyone else willing to pay attention.

Here's just a sampling of what you can find in your local camera store (or favorite online store):

✔ Camera bags and cases today come in virtually all sizes, shapes, and even colors (although a reliable camera-store source says that black is still by far the most popular color for a camera bag — go figure). Figure 2-7, for example, shows just a small assortment of styles from one manufacturer, LowePro (www.lowepro.com).

Figure 2-7: Five transport options from LowePro, shown left to right: Tasca (pink), Slingshot, Fastpack, Apex (lower), and Flipside.

Amy A. Timacheff

If you choose a backpack-style bag, a design like the Flipside pack shown in Figure 2-7 is a good idea: While you're wearing the pack, it can't be opened from the back, so you don't have to worry about someone reaching inside and snatching your camera while you're not paying attention.

✔ For fashion-conscious photographers, a few manufacturers offer products that look more like stylish handbags than camera cases. Check out one of the offerings from Jill-e (www.jill-e. com), shown in Figure 2-8, for example.

Figure 2-8: Cases like this one from Jill-e combine camera security and style.

Jill-e Designs, LLC

✔ If you need to transport camera equipment and can't actually carry it with you, you can choose from a number of very solid, watertight cases that cushion your gear in customizable foam and seal it from any potential outside hazard. Pelican Products (www.pelican.com) produces an extensive line; many professional photographers rely on this type of product when flying to ship expensive gear as checked baggage.

✔ For point-and-shoot cameras, an interesting protective and universal case called a Wrap-Up from Made Products (www.made-products.com) is available. You keep the case permanently attached to your camera by means of the tripod mount. When you want to shoot, you just unwrap the case (you can still use a tripod with the case attached). When you're done, you wrap it back up. Because the case never leaves the camera, it's one less thing to misplace or leave behind by accident. Figure 2-9 offers a look.

Figure 2-9: Basic protection, such as this Wrap-Up, may be all you need to keep your point-and-shoot camera safe.

Made Products, Inc.

✔ For photography in rugged conditions, several companies sell products that protect and fit your camera like a glove, literally. GGI International (www.ggiinternational.com) makes a wide variety of silicone *skins* that fully encase your camera, keeping out moisture and dirt, while still letting you operate it. Made Products (www.made-products.com) offers a line called

Camera Armor that provides similar protection for dSLR owners, while Kata (www.kata-bags.com) includes weather covers for shooting outdoors.

Seeking Software Solutions

Flashy and sleek, digital cameras are the natural stars of the digital-imaging world. But without the software that lets you get to your images, your digital camera would be nothing more than an overpriced paperweight. Because you probably already own plenty of other had-to-have-it, never-use-it devices that serve as paperweights, the following sections introduce you to a few software products that help you get the most from your digital camera.

Image-editing software

Image-editing software lets you change your digital photos just about any way you see fit. You can

✔ Correct problems with brightness, contrast, color balance, and the like.

✔ Crop out excess background and get rid of unwanted image elements.

✔ Apply special effects, combine pictures into a collage, and explore countless other artistic notions.

Today's computer stores, mail-order catalogs, and online shopping sites are stocked with an enormous array of photo-editing products. The next sections present some of the most popular options.

 Be sure to also find out what software, if any, came with your camera. Many camera manufacturers provide a selection of photo-editing tools on the software CD that ships in the camera box. Also note that many software companies post free, downloadable trial copies of their products on their Web sites.

Programs for beginners and casual photo editors

Several companies offer programs geared to the photo-editing novice or the digital photographer who only wants to perform simple photo surgery and creative artwork. Just a few choices in this category include

- ✔ ACDSee Photo Editor ($50, www.acdsystems.com)
- ✔ ArcSoft PhotoImpression ($50, www.arcsoft.com)
- ✔ Adobe Photoshop Elements ($99, www.adobe.com)
- ✔ Corel PhotoImpact X3 ($70, www.corel.com)

These programs provide all the basic image-correction tools that most casual photographers need, plus plenty of *wizards* (step-by-step on-screen guides), which walk you through different tasks. Figure 2-10, for example, shows the wizard feature of ACDSee Photo Editor.

Additionally, project templates simplify adding your photo to a greeting card, calendar, or photo collage, and you also get tools for creating slide shows, burning images to CDs, and more. And the nice thing about all the programs just listed is that although they provide easy, one-click corrections, they also offer some of the same higher-level tools that professionals use. So if you decide you're ready to tackle

some more advanced projects, you can do so without
buying a new program.

Figure 2-10: Consumer photo-editing programs, such as
ACDSee Photo Editor, make simple retouching projects easy.

However, not all programs aimed at the con-
sumer market offer a wide range of tools, so
read product reviews. Make sure the program
enables you to do the things you have in mind.
And keep in mind that if all you want to do is
simple repairs, such as removing red-eye and
cropping your photo, you may be able to get the
job done just using the software shipped with
your camera or some other free solution, such
as Google's Picasa (www.picasa.com). Another
possibility is a new Adobe service, Adobe
Photoshop Express (www.photoshop.com),
which offers tools that enable you to upload and
edit your photos online and then post the
results in Web albums.

Programs for advanced users and pros

If you edit pictures on a daily basis or want a little more control over your images, you may want to move up the software ladder a notch. Advanced photo-editing programs provide you with more flexible, more powerful and, often, more convenient photo-editing tools than entry-level offerings.

The downside to advanced programs is that they can be intimidating to new users and require a high learning curve. You usually don't get much onscreen assistance or any of the templates and wizards provided in beginner-level programs.

Figure 2-11, for example, offers a look at Adobe Photoshop CS3 (www.adobe.com), the industry-standard professional photo editor. As you can see, the program interface isn't exactly what you'd call intuitive. Expect to spend plenty of time with the program manual or a third-party book to become proficient at using the software tools.

Of course, Photoshop is several hundred dollars more than the less-advanced applications, too, selling for about $650. Fortunately, several good but less-expensive alternatives exist for users who don't need Photoshop's ultra-high power. Explore these options:

- ✔ ACDSee Pro ($130, www.acdsystems.com)
- ✔ Adobe Lightroom ($299, www.adobe.com)
- ✔ Apple Aperture, ($199, www.apple.com), shown in Figure 2-12
- ✔ Paint Shop Pro Photo X2 ($80, www.corel.com)

Figure 2-11: Adobe Photoshop is a top choice for serious imaging enthusiasts, but it has a steep price and steeper learning curve.

Specialty image software

In addition to programs designed for photo editing, you can find great programs geared to special needs and interests, including the following:

- ✔ **Image-cataloging programs:** These programs are designed to help you organize your pictures.

- ✔ **Slide show programs:** These programs make it easy to produce multimedia presentations

featuring your photos. Most image-editing applications offer some kind of slide show capabilities, but a few programs are dedicated to slide shows. Photodex Corporation (www.photodex.com), for example, provides a range of products.

Figure 2-12: Apple Aperture is a popular choice for people who need to quickly sort and retouch lots of photos.

✔ **Plug-ins:** A *plug-in* is a sort of mini-program that adds functions to a larger photo-editing program. For example, Figure 2-13 offers a look at nik Color Efex Pro (www.nikmultimedia.com). This plug-in package lets you create effects similar to those produced by traditional camera filters, as well as cool special effects. It works with many popular photo editors, including Photoshop and Photoshop Elements.

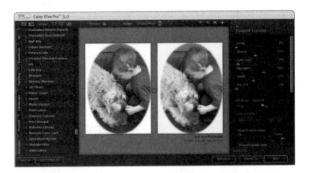

Figure 2-13: Special effects plug-ins, such as Color Efex Pro from nik multimedia, add more creative options to your photo-editing software.

Frequently, plug-ins are made for specific applications; for example, Essentials for Adobe Photoshop Elements (www.ononesoftware.com) complements and enhances Elements' capabilities to let you correct color, add frames, remove backgrounds, and enlarge lower-resolution images for printing in larger formats.

✓ **Digital painting programs:** With digital paint, you can create original artwork or use your photos to create images that have the look of traditional art media. Many image-editing applications offer special effects filters that let you do this to a degree, but a number of programs are designed from the get-go for painting. The most famous option — and as advanced as Photoshop in its own way — is Corel Painter. Figure 2-14 shows only a fraction of the artistic tools available in this program.

✓ **Scrapbooking software:** Scrapbooking is a very popular category with a number of great applications. What you used to do with glue, scraps of paper, buttons, and ribbons, you can now do

with special programs. Here are just two of the many scrapbooking programs available:

- Art Explosion Scrapbook Factory Deluxe ($40, www.novadevelopment.com)

- Creating Keepsakes Scrapbook Designer Deluxe by Encore, Inc. ($40, www.broder bund.com)

Figure 2-14: Corel Painter is unsurpassed as the most advanced application used to apply artistic effects to digital photographs.

Serge Timacheff

Getting Support from Tripods

A *tripod* is a three-legged stand, like the one shown in Figure 2-15, designed to hold your camera steady while a picture is composed and taken. Although a tripod might be a little cumbersome to carry along, at times, you'll find one indispensable. Here are some of the things a tripod can do for you:

Figure 2-15: Get the support you need from a tripod.

✔ Hold the camera steady for longer exposures. You need a longer shutter speed to capture an image in dim light.

✔ Hold the camera steady for photos taken at telephoto zoom settings. Telephoto settings do a great job of magnifying the image, but they also magnify the amount of vibration or camera shake. Even tiny wobbles can lead to photos that look like they're out of focus when they're actually just blurry from too much camera movement. A tripod can help eliminate this sort of blur.

 If pictures keep ending up fuzzy when the camera is set for its maximum telephoto zoom setting, it's more likely that the problem is camera shake than a poor autofocus mechanism. At long zoom settings, most digital cameras often switch to a

slower shutter speed. The slower shutter speed coupled with the telephoto's magnification of the tiniest bit of camera shake leads to a photo that appears out of focus. It's not that the picture is out of focus at all; it's just that the camera has been vibrating too much. If your camera or lens has a built-in anti-shake (vibration reduction/ image stabilization) feature, turn it on. If you don't have that feature or still experience blur caused by camera motion, mounting the camera on a good, sturdy tripod is the best cure for this problem. You can turn your image stabilization off while using the tripod.

✔ Hold the camera in place so you can get in the picture, too, by using your digital camera's self-timer feature. This way, you only have to worry about how you look as you make a mad dash into the picture. (Some cameras offer an infra-red remote control to trigger the shutter and avoid the mad dash; but you'll still need to mount the camera on a tripod or other support.)

✔ Allow for precise positioning and composition so that you can get exactly the image you want. This is especially important if you want to take multiple shots from the same spot, and it's also useful if you're experimenting with filters or trying different lighting ideas.

✔ Hold the camera for multipicture panoramic shots that you stitch together into one photo in your image editor.

✔ Hold the camera for close-up photography.

Because most modern digital cameras are fairly light-weight, you won't have to carry a massive tripod like many pros do; just be sure the tripod is strong enough to keep the camera steady. Beware of the models that claim to go from tabletop to full height

(roughly eye-level at 5 feet or more); odds are that they sway like a reed when fully extended. If you have one of the new, low-cost digital SLR cameras like those available from Canon, Nikon, Olympus, Sony, and Pentax, you might need a slightly heftier tripod because these models, although small for a dSLR, are a bit heavier than the run-of-the-mill digital point-and-shoot camera.

Types of tripods

Tripods come in several types of materials, styles, and sizes. Pro units are capable of handling heavy cameras and extending 5 to 6 feet high. These tripods are made of wood, aluminum, or carbon fiber and can cost anywhere from a couple hundred dollars to a thousand dollars or more. You probably don't want one of these. Your ideal tripod is probably a compact model made of aluminum. Here are the common types of tripods:

- **Less-expensive units:** May range in size from 1 to 5 feet tall and cost just a few dollars to a hundred dollars or more.

- **Full-size models:** These range from 4 to 6 feet tall (or even larger) when fully extended and might have from two to four collapsing sections to reduce size for carrying. The more sections, the smaller the tripod collapses. The downside is that the extra sections reduce stability and provide more points for problems to develop.

- **Tabletop or mini-tripods:** These are promoted as lightweight, expandable, and easy to carry, which they are. They can be small enough to carry around comfortably. They're also promoted as sturdy enough for a digital SLR, but they probably aren't unless set to their lowest height. Most can handle a point-and-shoot digital camera, however. If used on a tabletop or

braced against a wall with a small digital camera, these units do a decent job. They come in handy in places where there's not enough room to use a full-size tripod. Figure 2-16 shows a typical table-top tripod, which stands just 8 inches tall.

Figure 2-16: Tabletop tripods work great on tabletops!

 To use a mini-tripod against a wall, brace it against the wall with your left hand while pressing your left elbow into the wall. Use your right hand to help stabilize the camera while tripping the shutter. Keep your right elbow tight against your body for added stability.

✔ **Monopods:** While not exactly a tripod (a mono-pod has only one leg), a monopod helps reduce camera shake. These single-leg, multi-segment poles, like the one shown in Figure 2-17, about double the steadiness of the camera.

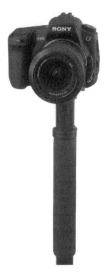

Figure 2-17: Monopods provide a more compact means of support for heavier cameras, like this digital SLR.

✔ **Hiking stick monopods:** Another option is a combination hiking stick/monopod. If you do a lot of hiking, these can be very worthwhile. Although not as sturdy or stable as a high-quality monopod, these hybrids can work quite well with the typical small digital camera. Most of them have a wooden knob on top that unscrews; a quarter-inch screw mates with the camera's tripod socket. (Check to make sure your digital camera has one; not all models do.) Mount the camera on the hiking stick, brace the bottom of it against your left foot, pull it into your body with your left hand, and gently squeeze the shutter release button.

You can find excellent tripods and monopods from Bilora, Bogen, Benbo, Gitzo, Lenmar, Slik, Sunpak, and Smith Victor at your photo retailer.

Scrutinizing tripod features

Not all tripods are made alike, so I encourage you to take a close look at how the tripod you're thinking of purchasing is put together. The following subsections are a rundown of what to look for.

Locking legs

All collapsible tripods offer some way of locking the legs in position. Most common are rings that are twisted to loosen or tighten the legs in place. Some manufacturers use levers instead. When buying a tripod, check this part closely. Remember, every time you want to fully extend or collapse the tripod, you're going to have six or more of these locks to manipulate. A good tripod lets you open or close all the locks for one leg simultaneously when the legs are collapsed, as shown in Figure 2-18. (Cover all three rings or levers at the same time with your hand and twist; they're all released, and then with one simple movement, they're all extended. This also works in reverse.)

Range of movement

Some tripod legs can be set to a right angle from the camera mount. This feature can be handy if you're working on uneven ground, such as a hiking trail.

Extra mounting screws

Some tripods offer an extra mounting screw on one of the legs. Hypothetically, this is useful, but its use is rare enough that I wouldn't choose one tripod over another for this. A more useful extra is a reversing

center column post, available on better tripods, that can accept a camera on its low end (for ground-level shots) or that has a hook that holds a weight or camera bag. Placing extra weight on a tripod makes it steadier for longer exposures, so this capability is very useful.

Figure 2-18: Grip all three locks to open or close them simultaneously.

Heads

A *tripod head* is the device that connects the camera to the tripod legs. On inexpensive models, these are

often permanently attached. On better quality models (although not necessarily expensive ones), they are removable and can be replaced with a different type. There are quite a few styles of tripod heads. Many tripod heads that offer a *panning* capability (the ability to spin or rotate the camera on its horizontal axis) also offer a series of 360 markings to help orient the camera for panoramas. Here are some of the types of tripod heads to consider:

- **Pan/tilt heads:** These allow you to spin the camera on one axis and tilt it on another. These are generally the cheapest and most labor intensive because you have to make adjustments to multiple levers to reposition the camera.

- **Fluid, or video, heads:** These usually have a longer handle that extends from the head. Twist the grip to loosen it, and you can pivot and tilt the camera simultaneously.

- **Joystick heads:** Similar to the fluid or video head, this type has a locking lever built into a tall head. By gripping the lever and head and squeezing, you can pan and tilt the camera quickly and easily. These were designed and marketed for 35mm cameras, but they don't work particularly well for these cameras because they're subject to creep. Basically, *creep* occurs when you reposition your camera on a tripod head, lock it, and then notice the camera move a little as it settles into the locked position. Creep can be a very annoying problem with any tripod head, but the joystick models seem to have more trouble with it.

For a smaller digital camera, these heads might be a better choice simply because these cameras weigh so much less.

✔ **Ball heads:** These are probably the most popular style with pro photographers because they provide a full range of movement for the camera with a minimal number of controls to bother with. This type of tripod head, shown in Figure 2-19, uses a ball mounted in a cylinder. The ball has a stem with a camera mount on one end, and when the control knob is released, you can move your camera freely until reaching the top of the cylinder. A cutout on one side of the cylinder allows the stem to drop down low enough for the camera to be positioned vertically. Ball heads range in price from just a few dollars to $500 or more. The best ones don't creep at all, which is why photographers pay so much for them.

Checking out tripod alternatives

Several other items on the market are also worth considering for those who need to travel light. A tried and true classic for supporting bigger camera/lens combinations is the beanbag. Whether you use the basic beanbag that you tossed around as a kid or the one specially designed for photography, by putting the bag on a wall or car roof and then balancing the lens on the bag, you can maneuver your equipment easily while letting the wall or car take the weight of the lens.

You can also find a number of clamp-like devices coupled with the quarter-inch screw necessary to attach them to your camera's tripod socket. You then clamp the camera to a tree limb or fence post or any other solid object, and *voilà!* Instant tripod. (Don't add water.)

These camera-holding clamps range from a modest C-clamp device for just a few bucks up to the Bogen Super Clamp system (which you can find at www.bogenphoto.com). The basic Super Clamp costs around $30. The basic C-clamp style should do the job for travelers using a shirt-pocket-size digital camera. Those working with one of the larger, digital SLR cameras might want to consider a Super Clamp. A local camera store can probably help you out.

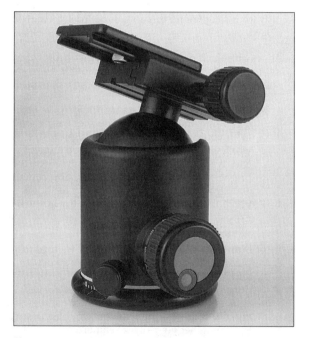

Figure 2-19: A ball head is the most popular style of tripod head for still photography.

Making Good Use of an Electronic Flash

Because available light (more commonly known as *available darkness*) is undependable, digital photographers should consider carrying an accessory flash unit. Although most digital cameras have some sort of built-in flash capability, these don't produce a very powerful light. The built-in flash unit is usually good only for a range of up to about 8 feet or so, which isn't always enough.

Accessory flash units do more than just provide extra light when it's too dark to shoot without it. Here are some situations in which an accessory flash is useful:

- ✔ **Fill flash:** Is your subject standing in the shadows while another part of the scene is brightly lit? If you rely on your camera's light meter, you'll either get a properly exposed subject and overexposed area where the light was too bright or an unrecognizably dark subject and an okay scene. Using an accessory flash lets you balance the light throughout the scene by exposing for the bright area and using the flash to light up the shadows.

- ✔ **Painting with light:** Suppose you want to take a picture of a building or other large structure, and it's pitch dark out. One technique for handling this situation is known as *painting with light*. Set your camera on a tripod or something equally solid and then pull out your accessory flash unit. Set your digital camera to its bulb (B) or time (T) exposure setting if it has one — or if not, then use the longest exposure (shutter speed) possible. While the shutter is open, use your flash to light up sections of the building one section at a time.

✔ **Macro, or close-up, photography:** Getting in close requires lots of light simply because as the camera gets closer to its subject, the area of sharp focus — *depth of field* — diminishes. Using your external flash helps provide enough light to allow an aperture setting for greater depth of field. The external flash also provides more-even illumination for your subject.

 It's best if you use a setup that allows your flash unit to operate while it's off the camera because lighting your subject from the side brings out more detail than lighting from straight ahead. Some flash units, such as ring lights, are specifically designed for macro photography.

✔ **Bounce flash:** Many accessory flash units include a tilt/swivel head that lets you point the unit toward a reflective surface instead of right at your subject. By bouncing the flash off the surface and toward your subject, you create softer light and shadows than you would if the flash was directed straight at your subject. Some include a built-in card or deflector that can help you direct the bounce light, as shown in Figure 2-20.

✔ **Multi-flash:** It's possible to use multiple inexpensive flash units to create a flattering lighting setup. By positioning these flashes properly, you can either create a nicer informal portrait lighting setup or distribute the lights well enough to evenly illuminate an entire room.

Built-in flash units can also speed the camera's battery drain tremendously. Because they're positioned right above the lens, the built-in strobes are also a prime cause of *red-eye*. This is a reddish tinge in human pupils (greenish or yellowish in many animals). Red-eye is particularly difficult to prevent

when photographing (with flash) young children. An accessory flash can help reduce this effect because you can position it farther from the lens than a built-in unit.

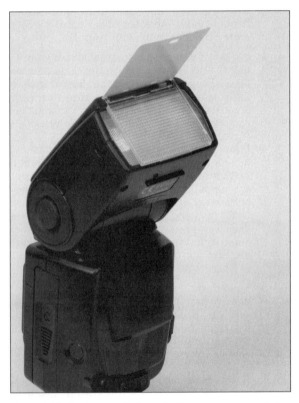

Figure 2-20: An external flash unit's light can be bounced off any available surface.

Many higher-end digital cameras offer some method of triggering an accessory flash unit, either by a cable connection or via a *hot shoe* — the device on a camera that holds an external flash and provides an electronic connection to the camera. Many amateur and advanced amateur digital cameras, however, offer no such provision. The answer in this case is a *slaved flash* (a flash that's triggered by the burst of light emitted by another electronic flash unit) specifically designed for digital cameras (which I discuss in more detail in the next section).

Types of electronic flash units

There are as many different electronic flash units available as there are digital cameras. The following subsections provide a quick rundown of the kinds you'll want to consider.

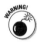

Before buying flash equipment of any kind, be sure it works with your camera. Flash units can be triggered via the camera's hot shoe, by electronic slaves, by wireless radio triggers, and via several different types of cables. Some cameras can use a generic, old-fashioned connection called a *PC cable* (not named for a personal computer but for the Prontor-Compur shutters of the early film cameras that used this connection). These cables are inexpensive and work with any camera that has a PC connection, but all they do is trigger the flash unit.

A camera's manufacturer makes another type of cable, known by several different designations (TTL and E-TTL, for example); this proprietary type is designed specifically for the manufacturer's cameras (sometimes for just one segment of its camera line) and no other, although these cables do work with third-party flashes. The advantage to these types of flash cords (which are much more expensive than PC

cords) are that they allow the camera and flash unit to communicate with each other so that the camera can turn the flash's output off when it determines proper exposure is reached.

Small, light minislaves

Minislave units are electronic flash devices with built-in remote triggering, and they're designed to help augment the camera's built-in flash unit. They're generally useful for adding a little extra dimension to your lighting and as a way of filling in background areas. These units are slaved to fire when another flash unit goes off. Such photographic slaves are photoelectric sensors designed to trigger a flash unit when another flash is fired within the sensor's field of view (in the case of a digital camera, when the camera's built-in flash fires). These slave-triggering circuits are sold as independent units that you can attach to existing flash units, or the circuitry can be built right into a flash.

Hot shoe mount flashes

These are more powerful than both the minislaves and the camera's built-in flash units. They might or might not offer a tilt or swivel capability. Some camera systems (usually higher-end digital cameras) offer a cable that hooks up to the camera's hot shoe and allows the flash to communicate with the camera's electronics while being positioned in ways the hot shoe mount won't permit. The advantage to these cables over slaves is that they usually permit the camera/flash combo's full range of capabilities. (Some cameras are set to turn off the flash as soon as the correct exposure is reached, whereas a slaved flash will continue pumping out light as set.)

Professional flash models

While you probably won't be venturing into this territory, you might want to know that professional flash units tend to be the manufacturer's most powerful and most advanced models. They have lots of features, including built-in slave capabilities and the ability to work with wireless remote systems. In many cases, they're also capable of taking advantage of the digital camera's lack of a true mechanical shutter at higher shutter speeds. This means the flash can be used with faster shutter speeds than those used with film cameras. In addition to the manufacturer's flash models, dedicated flashes offered by third-party manufacturers also work with many existing camera systems.

What to look for in a photographic slave flash

A basic *slave unit* is a small device designed to mate with the flash unit's hot shoe or other connection. The slave (good ones have on/off switches) triggers the flash when another flash unit is fired. A slave has its own hot shoe foot (to mate with stands designed for such things or the L-bracket described in a few paragraphs) and a quarter-inch tripod socket in its base so that you can screw it onto an extra tripod.

Wireless or radio slaves also exist. These are significantly more expensive (although I paid just $75 for my radio unit), but they're worth it when other photographers and their accompanying flashes are in the vicinity. A regular photoelectric slave doesn't care that it's been triggered by the wrong photographer's

flash unit; it simply does its job. Wireless triggers
work via radio signals, not light. These devices gener-
ally offer multiple frequencies to minimize the likeli-
hood of another photographer triggering them.

A standard photographic slave won't work prop-
erly with a digital camera because most pro-
sumer and amateur digital cameras emit a
preflash (to help the camera make some internal
settings), which triggers earlier slave designs
prematurely. If you're interested in a slaved
flash unit, make sure it's designed to work with
a digital camera. Nissin, an electronics firm,
makes a flash unit known as the Digi-Slave flash.
You can find about a half-dozen different units,
ranging all the way up to a pro unit. Check out
SR, Inc. (at www.srelectronics.com), for pictures
and descriptions of the models available.

Although the slaved flash doesn't help reduce the
drain on the camera's battery, the more powerful light
still helps improve photos. The photographer also
gains the ability to position the light higher up from
the lens (usually slightly to the right or left as well) to
reduce the likelihood of red-eye and provide a more
pleasing effect. Generally speaking, setting the cam-
era's exposure system to automatic can handle the
increased flash okay; if you're not satisfied with the
result, switch to your camera's aperture priority mode
(which allows you to choose the f-stop while the
camera selects the shutter speed) and experiment! The
exception is with close-up photos, where overexposure
is likely. Dialing in a correction (usually a reduction of
about two f-stops) through the camera's exposure
compensation system solves this problem.

Acquiring Other Useful Devices

Gizmos. Gadgets. Thing-a-ma-jigs. Many of these items don't fall into any particular type of category, except that they do something useful. Some are quirky but cool, such as little shades that fasten onto the back of your camera and shield your LCD readout screen from the bright sun. Others are serious working tools, like the add-on battery packs described in an upcoming section. Photographers love gadgets, and you'll find lots of them for digital cameras. Here are a few of the most practical.

A filter holder

A helpful device I especially like is a filter holder engineered by the Cokin company (www.cokin.com) and sold by most camera outlets. One Cokin holder, designed for cameras that can't accept filters, mounts to the base of the camera via the tripod socket. This adapter allows the use of Cokin's square filters and circular filters (see Figure 2-21), which slide right into the adapter to provide a variety of effects and corrections.

Note, however, that you could achieve many of the same results in an image-editing program. To those who are more comfortable tweaking things on the computer, filters aren't important. But, if you're new to computer photo editing, relying on traditional filters might be easier.

You can always take one shot with a filter and one without and then try to tweak the filterless shot to look like the filtered one. This process can help you figure out how to get the most from your image-editing software.

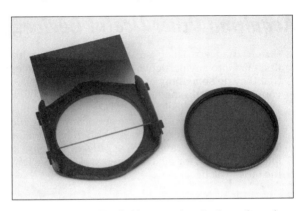

Figure 2-21: Cokin filter holders attach to the front of your lens and accept square and round slide-in filters.

Filters

Filters, those glass disks that can be screwed onto your camera's lens, are a popular accessory. Here are some of the different kinds of filters you can buy and play with:

- ✔ **Warming:** Some filters produce what photographers refer to as a *warming effect*. This filter can help make up for the lack of color in midday light and tries to add some reddish-orange color to the scene. Usually, these are coded in the 81 series (as in 81A, 81B, and 81C). At the camera store, just ask for a warming filter.

- ✔ **Cooling:** These do just the opposite of the previous type. They add blue to the scene to reduce the reddish-orange color. These fall into the 82 series for daylight conditions.

- ✔ **Neutral density:** Another type of filter reduces the amount of light available. These neutral density (ND) filters (*neutral* because they have no

color, and *density* because they block light)
come in handy for things such as achieving the
spun-glass effect from moving water. The filter
blocks an f-stop's worth of light or more, making
a slower shutter speed possible and increasing
the blur of the moving water. You can use ND fil-
ters to operate at a wider aperture to blur the
background in portraits, too.

✔ **Neutral density, take two:** Sometimes a photog-
rapher wants to photograph a street scene with-
out cars driving through the photo. By stacking
neutral density filters, it's possible to create
such a long exposure that no cars are in the
scene long enough to register in the image.
Obviously, a camera support of some sort is
required. (***Hint:*** The ground's pretty stable, too,
unless you're visiting California.) Having a
camera capable of extremely slow shutter
speeds is also necessary. A neutral density filter
is shown in Figure 2-22.

✔ **Split neutral density:** Another version of the
neutral density filter is a split neutral density
design. This filter provides half neutral density
and half clear filtration, preferably with a gradu-
ated transition from the light-blocking half to
the clear half.

The main use for a split ND filter is for occa-
sions when half the scene is brighter than the
other. The most common example of this is a
bright sky against a significantly darker fore-
ground. This condition is typical of midday
lighting conditions.

✔ **Polarizers:** Polarizing filters can reduce the
glare bouncing off shiny surfaces in your
photos. Simply attach the filter and view the
image through your LCD. Rotate the polarizer
until the glare disappears. Polarizers can also
help deepen the contrast of the sky from certain
angles.

Figure 2-22: A neutral density filter reduces the amount of light reaching the sensor.

A second camera

Sooner or later, you'll think about buying a second camera — say, when you're ready to leave on that vacation of a lifetime. A small, inexpensive digital camera doesn't cost much, and if the primary camera fails, it might prove worth its weight in gold, photographically speaking. Shop for one — or borrow one — that uses the same type of batteries and storage medium as your primary camera, if possible. The extra camera can also entice a spouse or child into sharing your love of photography.

Second cameras are easy to come by. Every time I upgrade to a new digital camera, the old one gets passed down to a family member or kept in reserve as a spare camera. My old 3.3-megapixel Nikon Coolpix 995 was great in its day, but it became a backup when

I upgraded to an EVF model with a super-sharp 8:1 zoom lens. Then digital SLRs came along and eventually I ended up with a Nikon D300 as a "main" camera and the incredible, super-compact Nikon D60 as an everyday backup.

Waterproof casings and housings

Extreme conditions call for better protection for your camera. Better yet, photography in wet weather, or even underwater, can be fun, too. Waterproof casings that still allow for photography are available from several companies, including ewa-marine (www.ewa-marine.de). These are useful for both underwater photography (careful on the depth, though) and above-the-water shots when you're sailing or boating. Keep in mind that salt spray is very possibly the single worst threat to camera electronics. Make sure your camera casing provides good protection against wind and salt spray.

Another option for those who want to shoot in wet conditions often is a new underwater digital camera. The SeaLife ReefMaster underwater digital camera series (www.sealife-cameras.com) comes in a waterproof housing and works both on land and underwater. The cameras, which can be purchased for as little as $400, produce 3.3- to 5-megapixel images, and they save you the trouble of trying to find a housing to fit an existing digital camera. The cameras also have an LCD that works underwater and a fast delete function to make it easier to operate underwater.

For serious underwater enthusiasts, heavy-duty Plexiglas housings now exist for small digital cameras. These housings are available for a wide range of digital cameras and may be found for as little as a couple hundred dollars.

Battery packs

One of my digital cameras uses a lithium-ion (Li-Ion) rechargeable battery that's good for a couple hundred shots. Unless you're involved in a serious photographic project or leave home on vacation, a single battery (plus one spare) might be all you need. However, that same camera can be fitted with an add-on battery pack that fits under the camera body and holds two more of the same model Li-Ion batteries (increasing the shooting capacity to nearly 600 shots). More importantly, the accessory battery pack accepts standard AA batteries, which the camera itself does not.

You'll find an add-on battery pack like this extremely useful for those shooting sessions that involve treks into back country far from AC power. Or if you're on vacation, you might be unable to recharge your digital camera's batteries until you check into your next hotel, so the additional juice might be handy. If you need an accessory battery pack, you probably also need a charger that works on multiple voltage settings (so it can be used overseas) or with an automobile connector so that you can recharge your batteries on the road.

Chapter 3

The Digital SLR Advantage

*T*he digital single-lens reflex (dSLR) camera is replacing point-and-shoot models for all photography beyond simple snap-shooting. Certainly, pocket-sized digital cameras are useful as carry-anywhere picture takers for unplanned and spur-of-the-moment shooting. But now that dSLRs are available in ultracompact packages for ultra-low prices, serious photographers seem unwilling to settle for anything else. Virtually everything you can do with a traditional digital camera, you can do with a dSLR — faster, with more creative options, and usually with a better picture.

Working with what most amateur photographers used to consider the high end of the digital photography equipment realm won't make you a better photographer.

But upgrading to a dSLR will probably make you a *happier* photographer, particularly after you've mastered all the new controls and features these cameras offer.

Single-lens reflex cameras are film or digital picture takers that use mirrors and/or prisms to give you a bright, clear optical view (not a TV-like LCD view) of the picture you're going to take, using the same lens that is used to take the picture. Best of all, that lens can be *taken off* (it's *interchangeable*) so you can substitute another lens that brings you closer to your subject, offers a wider view, or maybe focuses down close enough to see the hungry look in the eye of a praying mantis. Is that cool, or what?

Whether you already own a dSLR or you're thinking of buying one, this chapter and the one that follows are your introduction to the exciting features of these top-of-the-digital-food-chain cameras. If you want to find out more, check out *Digital SLR Cameras & Photography For Dummies,* by David D. Busch, but everything you really *must* know right off the bat is in this book.

Six Great dSLR Features

All digital SLRs have six killer features that make your job as a photographer much easier, more pleasant, and more creative.

A bigger, brighter view

The perspective through a dSLR's viewfinder is larger and easier to view than what you get with any

non-SLR's optical window, back-panel LCD, or internal
electronic viewfinder (EVF). With a dSLR, what you
see is almost exactly what you get (or at least 95 per-
cent of it), although you might need to press a button
called a *depth-of-field preview* if you want to know
more precisely what parts of your image are in focus.
The dSLR's viewfinder shows you a large image of
what the lens sees, not a TV-screen-like LCD view.
(See Figure 3-1.) If you have your heart set on using
an LCD, many of the latest digital SLRs from Canon,
Nikon, Olympus, Sony, and Pentax offer a feature
called Live View, which displays the actual sensor
view on the LCD prior to taking the picture. And as
with any digital camera, you can still review the pic-
ture you've taken on your dSLR's LCD after it has
been captured. (See Figure 3-2.)

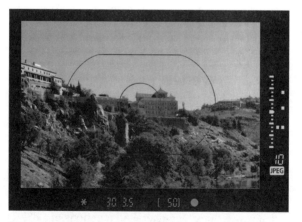

Figure 3-1: A dSLR viewfinder gives you a big, bright view of
your scene for easy composition and focus.

Figure 3-2: You can review your image on your dSLR's screen after it has been captured.

Faster operation

Any non-SLR digital camera suffers from something called *shutter lag,* which is a delay of 0.5 to 1.5 seconds (or more) after you press the shutter release all the way but before the picture is actually taken. Lag is a drag when you're shooting sports action or trying to capture a fleeting expression on the faces of your kids. A dSLR responds to your command to shoot virtually instantly and can continue to take pictures at a 3 to 5 frames-per-second clip (or even faster). Try *that* with a non-SLR camera! All functions of a dSLR camera, from near-instant power-up to autofocus to storing an image on your memory card, are likely to operate faster and more smoothly with a dSLR than with other types of digital cameras.

Lenses, lenses, and more lenses

Certainly, many non-SLR cameras are outfitted with humongous zoom lenses with 12X to 18X zoom ratios. A typical superzoom range is the equivalent of 35mm to 420mm on a full-frame digital or film camera. Yet, these lenses don't do everything. Only a digital SLR, which lets you pop off the lens currently mounted on your camera and mount another one with different features, has that capability. Non-SLR digital cameras rarely offer wide angle views as broad as the equivalent of 24mm to 28mm. Digital SLR lenses commonly offer views as wide as 10mm. You'll also want a dSLR if you need to focus extra-close or want a *really* long telephoto. The lenses offered for dSLR cameras are often sharper, too. For many photographers, the ability to change lenses is the number-one advantage of the digital SLR.

Better image quality

You'll find non-SLR digital cameras today with 8 to 14 megapixels of resolution. (There are even *camera phones* with resolution in that range.) But a good-quality dSLR will almost always provide better image quality than a traditional digital camera of the same or *better* resolution. Why? Because the dSLR's sensor has larger pixels (at least 4 to 5 times larger than the typical point-and-shoot camera's), which makes them more sensitive to light and less prone to those grainy artifacts we call *noise.* A 10-megapixel dSLR usually provides better images with less noise at a sensitivity setting of ISO 800 than a 10-megapixel non-SLR camera at ISO 400.

Camera-like operation

The workings of a non-SLR digital camera have more in common with a cell phone than with a traditional film camera. If you don't like zooming by pressing a button, visiting a menu every time you want to change a setting, or fine-tuning focus with a pair of keys, you should be using a digital SLR.

More control over depth of field

Depth of field (DOF) is the distance range in which things in your photos are in sharp focus. DOF can be shallow, which is a good thing when you want to make everything in your image other than your subject blurry, so that your subject is isolated or highlighted. Depth-of-field can also be generous, which is great when you want everything in the picture to look sharp.

Digital SLR cameras allow you to choose between shallow DOF, extensive DOF, and everything in between. Non-SLR cameras usually give you two choices when you're not shooting close-up pictures: having everything in sharp focus, and having *virtually* everything in sharp focus. You can find out more about the technical reason for this (the extra depth of field provided by the shorter focal length lenses used in non-SLR cameras) in Chapter 4. If you want to use focus creatively, a dSLR is your best choice.

Six dSLR Drawbacks That Are Ancient History

Wow, can technology change quickly in the digital camera realm! In the last edition of this book, I listed six drawbacks of digital SLRs that you probably could

live with. Shazam! Two years later, all six have (mostly) bitten the dust. Not only can dSLRs do many things that non-dSLRs can't, their limitations are becoming fewer and fewer all the time. Here's a recap of those drawbacks that have now become, for the most part, ancient history:

No LCD preview? Meet Live View!

"Where's my preview?" was the number-one question asked by new dSLR owners who started out using conventional digital cameras. Because the mirror and shutter of a dSLR block the sensor from receiving light until the moment the picture is actually taken (I discuss this in more detail in the "How Digital SLRs Work" section later in the chapter), it formerly was impossible to offer a preview image prior to taking the picture. That limitation has been licked.

The leading dSLR vendors now offer a Live View feature that shows, in real time, the image being captured by the sensor. Figure 3-3 shows a Live View picture in action, with a Canon EOS Digital Rebel XSi. Most cameras offer a choice of hand-held and tripod modes; automatic focus is provided either by flipping the mirror back down for an instant prior to exposure so the normal autofocus functions can be applied or focusing of the LCD image itself.

Live View is handy for close-up photography, remote picture taking, and other situations where you want to monitor the actual image before taking the picture.

Figure 3-3: Live View allows you to preview your image on the LCD.

Limited viewing angles? No longer!

With previous dSLRs, you always had to have your eye right up to the viewfinder to line up your shot. And when reviewing your pictures, you usually had to look at the back of the camera straight-on. Showing your pictures to several friends who tried to view the screen from an oblique angle was a pain.

All that's changed. You can, of course, buy add-on viewing attachments (including right-angle adapters) that can give dSLR owners a little more flexibility when composing a shot through the optical view-finder. But the growing number of cameras that offer an LCD Live View preview, particularly those with a swiveling LCD, let you hold the camera at arm's length, overhead, or down low to compose your pictures. Today's LCDs allow wider viewing angles, too, so you can glimpse your screen from off to the side — and so can your friends.

Lack of super-wide lenses? Improvements made!

If your dSLR has a sensor that is smaller than 24mm x 36mm (a 35mm film camera's full frame), the perspective of each lens is cropped by this smaller sensor size, increasing the focal length's effective field of view by 1.3X to 2X, depending on the dSLR you're using. (The focal length isn't really multiplied, however.) This factor is good news for those who want to reach out with a longer telephoto lens, but it's bad news for those who find their 20mm super-wide-angle lens has become an ordinary 26mm to 40mm moderately wide or normal lens.

In the past, super-wide-angle lenses for dSLRs were rare and expensive. But the manufacturers of digital SLRs and third-party lens vendors like Tamron, Sigma, and Tokina have come to the rescue. Extra-wide lenses are now readily available, and at somewhat lower prices. My favorite is a 10–17mm fisheye zoom lens from Tokina (by way of the Pentax optical labs). It allows me to take ultra-wide shots I never could get before.

Dirt and dust? Automatic cleaning has arrived!

Virtually all current dSLRs have automatic cleaning features, which relieve your sensor of the dust and dirt that infiltrates your camera each time you swap lenses. While this dirt is often invisible in your final photos, you'll see it in large, plain, light-colored areas of your image (such as the sky) in photos taken with smaller f-stops (which provide extra depth of field that brings the dust into sharp focus). In the past, many of us faced a weekly or monthly chore of locking open our shutters and cleaning the sensor with a

blast of air, a brush, or a swab moistened with a cleaning fluid.

Today, your sensor probably shakes off that dust automatically every time you turn your camera on or off (or both).

No movies? Not always!

One digital SLR from Nikon allows creating *stop motion* movies right in the camera. You can assemble your silent movie from a continuous series, edit the clip, and view it on the camera's LCD, or you can transport the mini-film to your computer. Other dSLR vendors should offer a similar feature soon.

Of course, dSLRs still can't take true motion pictures like those possible with many digital snapshooting cameras. Most point-and-shoot models can take movies with sound at TV-quality 640 x 480 pixels at 30 frames per second (fps). Although most of these cameras will never replace a true camcorder, it's handy to have this capability for spur-of-the-moment movie clips. Alas, the fastest professional dSLR is capable of snapping shots at no more than about 8 fps and would be mechanically incapable of shooting 30 fps movies even at a drastically reduced resolution. If you want real movies *and* dSLR stills, you're going to have to carry two cameras.

Too much weight and size? The gap is narrowing!

Digital SLR cameras still can't be slipped into a pocket — unless you're a kangaroo — but the smallest weigh not much more than the largest of their non-SLR counterparts. Electronic-viewfinder and

superzoom cameras can be huge, too. Some dSLRs are smaller than others, and the latest from Nikon, Canon, Pentax, and Olympus are truly petite. If you want to have a camera with you at all times (and you should!), you'll need to get one of these smaller dSLR models or buy a second, ultracompact snapshooting camera as a constant companion.

How Digital SLRs Work

As you might expect, there are some differences in the way digital SLRs capture pictures. Knowing a little of the inside dope on these cameras can help you understand how best to use their features.

Like their non-SLR counterparts, digital SLRs rely on sensors composed of an array of pixels. But because the sensors are larger in a dSLR, the pixels are larger, so most 12-megapixel dSLRs produce sharper and more noise-free results than 12-megapixel non-dSLRs. Some dSLRs even outperform other dSLRs with greater resolution because of the quality of the sensors, lenses, or electronic circuitry. So, with dSLRs as with other types of digital cameras, the raw number of megapixels is only a guideline, even though more pixels is often better.

You might not actually need all that extra resolution, especially when you consider that every million pixels you stuff into a digital SLR adds up to a more expensive camera that might not actually give you better results. Those extra pixels fill up your memory cards: My first dSLR could fit 150 highest-resolution photos on a 1GB CompactFlash card; my newest requires a 4GB card for 190 photos.

In the same vein, I had to upgrade my hard drive to store those larger images and switch from CD to DVD

and external hard drives for archiving. Those bigger photo files take longer to transfer from my card reader to my computer, and I needed more RAM and a faster processor to edit them in my image editor. The demands of multiple megapixels probably won't dissuade you from buying that advanced camera you've been lusting after, but you should keep the equipment requirements of your upgrade in mind.

Digital SLRs include the following parts (shown in Figure 3-4):

- ✔ **Lens:** This optical component captures light and focuses it on your sensor. Usually, a lens on a digital camera is of the *zoom* variety, which can change focal lengths at your command to provide more or less magnification of the image. However, with a dSLR, the lens may also be a fixed focal length or *prime* lens. Digital SLR lenses are removable and interchangeable.

- ✔ **Aperture:** This opening inside the lens can be adjusted to allow more or less light to reach the viewfinder and sensor. Non-SLR cameras may offer only a very limited number of apertures (or *f-stops*), sometimes only one in addition to the maximum aperture (the largest lens opening available). Lenses for dSLRs usually include a full range, from the largest (often f/2.8 or larger) to the smallest (frequently f/22 or smaller).

- ✔ **Viewing system:** Non-SLR cameras may have an optical window to supplement the back-panel LCD that provides an image of what the sensor sees. As I mention earlier in this chapter, older dSLRs have no such LCD preview but instead use a mirror that bounces the light received from the lens to other mirrors or to a prism for inspection through what is called an *eye-level viewfinder.* This system requires some mechanism for flipping the mirror out of the way when the picture is taken, plus a ground-glass or

plastic focusing screen that the reflected image is formed on. Newer dSLRs offer an option called Live View that provides a real-time preview of the image that will be taken.

✔ **Shutter:** Non-SLR cameras usually control the length of the exposure with an electronic shutter, which briefly sensitizes the sensor and then turns it off. Digital SLRs, too, often use an electronic shutter for the very briefest shutter speeds, usually those no longer than 1/180 to 1/500 of a second — the slowest electronic shutter speed varies from dSLR to dSLR. But these cameras also use a mechanical shutter located just in front of the sensor (at the *focal plane*) that exposes the sensor for a period of time by opening a curtain that travels over the surface of the sensor, followed by a second curtain that makes the same trip to cover the sensor back up. This focal plane shutter handles exposures from 30 seconds or longer down to 1/180 to 1/500 of a second (depending on the camera).

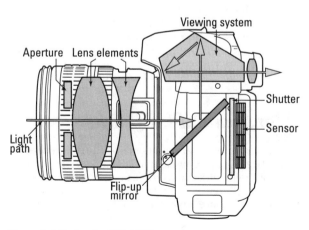

Figure 3-4: Parts of a digital SLR.

- ✔ **Sensor:** All digital cameras use a sensor, as described in Chapter 1. Digital SLR sensors are larger, more sensitive to light, and produce less noise at a given sensitivity setting.

- ✔ **Storage:** A digital SLR has very fast internal memory, called a *buffer,* which accepts each image (actually, a series of images, enabling your dSLR to take one picture after another). Like other types of digital cameras, the dSLR also has a removable memory card, usually a CompactFlash, SD, or xD Picture Card, that stores the images as they are written from the buffer.

The size and speed of your digital camera's buffer and the writing speed of the memory card determine how many pictures you can take in a row. Digital point-and-shoot cameras generally let you take between 5 and 30 shots consecutively and in continuous bursts of about 2.5 to 8 frames per second. When your buffer fills, the camera stops taking pictures. However, as the buffer fills, the dSLR will simultaneously write some of the pictures to your memory card, freeing up space for more pictures. So, a faster memory card (they are measured in relative speed, such as 40X, 80X, 133X, and 300X) allows you to take more pictures consecutively, making your camera's built-in buffer that much more effective.

Managing dSLR Quirks

Earlier in this chapter, I describe the differences between a dSLR and a non-SLR camera. Whether you call them quirks, idiosyncrasies, or foibles, most of these differences, like the faster operation and lack of shutter lag, are advantages that you can benefit from.

Others, such as lack of an LCD preview if you have an older dSLR, are things you must simply get used to. But other dSLR quirks command a bit of your attention. The three most demanding idiosyncrasies are detailed in the following sections.

Noise about noise

If you date back to the film era, you might recall that film came in various speeds or sensitivities, represented by ISO ratings. (ISO is the name chosen by the International Organization for Standardization, but it isn't an acronym.) You probably purchased an ISO 200 film for everyday use, perhaps a slower ISO 100 product when you wanted a less grainy picture or because you believed these films provided better quality. If you planned to shoot under low light levels or needed fast shutter speeds, you might have purchased an ISO 400 film.

Digital camera sensitivity is measured in ISO-equivalent settings, too, but, in truth, each digital sensor has only one *actual* ISO sensitivity — usually the lowest setting available for that camera. This minimum ISO setting varies from ISO 50 to about ISO 200, depending on the camera. All other ISO settings are created by amplifying the signal captured by the sensor, so photons that were almost too dim to register are electronically beefed up to become full-fledged pixels.

Unfortunately, at the same time, non-photons are mistaken for true pixels and assigned pixel-hood even though they don't deserve it. These bogus pixels are what photographers call *noise,* and unless you *want* a grainy look to your photos, noise is usually a bad thing. Noise appears in your pictures as multi-colored flecks that look like grainy, irregular dots.

Other factors cause noise, too. If an exposure is very long, some spurious pixels can be produced, often because the sensor heats up after being sensitized for a long period (about a second or more). Some kinds of electrical interference can also produce noise in your images.

Non-SLR cameras are the worst in the noise department, which is why most snapshooting cameras do their best work at ISO 400, although a few cameras now go all the way up to ISO 1600–3200 (with mixed results). Digital SLRs have a distinct advantage. They have larger pixels, which are more sensitive to light because they have more area to capture photons. So, virtually all digital SLRs can be used at ISO 800 with little noise, and many go up to ISO 3200. The very best performers tend to be the full-frame dSLRs, such as the Canon EOS 1Ds Mark III and Nikon D3, which have the largest pixels of all.

If you're new to dSLRs, you may be unfamiliar with the possibilities of high ISO shooting and, in particular, the relative image quality your own camera produces at various ISO settings. Take the time to capture a few shots at each available setting to find out what your dSLR can and can't do.

You'll want to figure out how to use your camera's noise reduction (NR) features to reduce problems like those shown in Figure 3-5. Depending on the model you own, NR may be applied automatically to high ISO settings but be optional for longer exposures. Or your camera may have separate user-defined settings for each type of noise. Excessive noise reduction can reduce the amount of detail in your image, so you should find out exactly how to use your camera's NR features. You'll also want to find out how to apply noise reduction after the picture was taken by using software like Adobe Camera Raw, Noise Ninja, or the filter built into Photoshop.

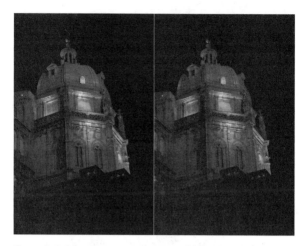

Figure 3-5: A long exposure at a high ISO (left) with noise reduction applied is not contaminated by the multicolored specks we call noise, seen in the example at right.

The real dirt on sensors

It might take awhile, especially if your camera has automatic sensor cleaning, but eventually you'll get some dust on your dSLR sensor that absolutely has to be removed manually. A camera's automatic sensor-shaking cleaning can only go so far, and some kinds of dust are sticky and stubborn. Don't panic! The process isn't difficult or dangerous, but you can take the following steps to minimize the number of times you'll have to clean your sensor:

✔ **Minimize dust entry.** If you point your camera downward when changing lenses, dust particles are less likely to settle into the mirror compartment.

✔ **Don't provide dust with a safe haven.** Make sure the mounts of your lenses and the rear lens elements are clean and dust-free when you attach a lens to your camera.

✔ **Think clean.** Try to change lenses in relatively clean environments. Avoid dusty rooms or gusty outdoor locations.

✔ **Minimize the time your camera is lensless.** Have your new lens ready to mount, with the rear cap off but placed loosely on the back of the lens. Then, remove the lens that's already on your camera, set it down, and immediately take the rear lens cap off the new lens. (Set it on the back of the old lens if you can do it quickly.) Then pick up the lens to be mounted and fasten it as quickly as you can. It's okay to leave the old lens naked for a few seconds if you're careful — you can always clean dust that settles on it later. The goal is to get the old lens off and the new one attached as quickly as possible.

Do a Google search for *"sensor cleaning"* to find extensive discussions on the various ways of cleaning digital SLR sensors. You can use specially designed bulb blowers to waft the dust off, certain types of soft brushes to remove more firmly attached particles, and moist swabs to get the really stubborn artifacts off. Don't use general-purpose products intended for cleaning lenses or your vehicle's dashboard. Your Google quest will provide all the information you need to do it right.

Going in crop factor circles

As I note earlier in this chapter, many digital SLR cameras use a sensor that is smaller than the 35mm film

frame. Even so, many vendors (Olympus is a notable exception) rely at least partially on lenses that were originally designed for these full-frame film cameras. Although many digital-only lenses are being introduced, there is still a momentum of thinking of optics in terms of the 24mm x 36mm format.

That means that if you cut your teeth on 35mm cameras, the apparent focal lengths of your dSLR camera's lenses are likely to seem wrong to you. The smaller sensors cause the image to be cropped, so a 50mm normal lens becomes a mild telephoto. A 105mm portrait lens that you used to take head-and-shoulder shots with a film camera might not be such a good choice for portraits anymore. (For one thing, you'll have to take a few steps backward to keep your subject within the frame.)

And, of course, your wide-angle lenses might not be so wide when cropped by your sensor. This effect is sometimes called, inaccurately, a *multiplication factor* or lens *multiplier* because the easiest way of representing the effect on the camera's field of view is by multiplying the focal length of the lens by the factor. A 100mm lens becomes a 150mm lens with a camera that has a 1.5X crop factor.

Of course, in truth, no multiplication is involved. That 100mm lens is still a 100mm lens and has the same depth of field. Your 180mm f/2.8 optic isn't magically transformed into an amazing 360mm f/2.8 super-telephoto. You could get the same effect and look by shooting a picture on a full-frame camera and then cropping it. That's why the correct terminology for this effect is *crop factor*. Common crop factors with today's dSLRs are 1.3X, 1.5X/1.6X, and 2X, as shown in Figure 3-6.

As a dSLR user, you need to become accustomed to thinking about this factor as it really is — as a crop rather than multiplication factor. That will help you better understand what is going on in your camera, although it won't eliminate all the confusion that results from trying to equate your 70mm to 200mm (actual focal length) lens with what it really is in dSLR terms. The good news is that you'll eventually get used to the crop factor and begin thinking of 30mm as a normal lens focal range and a 50mm lens as a portrait lens.

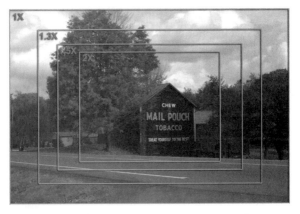

Figure 3-6: Crop factors change the effective view of your dSLR's lens.

Chapter 4

Working with Lenses

All digital cameras have lenses, of course. Digital SLR owners just have more of them to choose from. The ability to change lenses is one of the top advantages of the digital single-lens reflex camera, especially for those who want to go longer, wider, deeper, or closer or want to shoot in less light. If the lens currently mounted on your camera doesn't do what you want, just remove it and replace it with one that does (assuming you have the funds to *afford* your dream optics).

This chapter concentrates on the special things you can do with the interchangeable lenses available for dSLRs.

Optical Allusions

You'll find references to a disease called *lens lust* all over the Internet. It's that strange malady that strikes dSLR owners when they discover just how much more they could do if they just had this or that particular lens.

Unfortunately, no single lens can do every job, although a few come close. Several vendors offer an 18mm to 200mm zoom lens (see Figure 4-1 for an example of one with camera-shake-nullifying vibration reduction built in) that covers most of the focal lengths you need for everyday shooting. But even that lens won't give you ultra-wide-angle shots or superzoom perspectives, and it won't operate well at light levels that call for a large maximum aperture (say, f/2 or f/1.4).

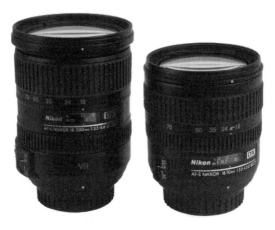

Figure 4-1: An 18–200mm lens with built-in vibration reduction (left) and a less expensive 18–70mm lens furnished with several digital SLRs as basic equipment.

So choosing the right lens is important when you want the best lens for a particular job. Here are some of the things that the right lens can do for you:

 ✔ **Shoot in low light.** The basic zooms furnished with most digital SLRs have maximum apertures of f/3.5 to f/4.5, which is much too slow to be

useful in low light levels. You can choose other zooms with f/2.8 maximum apertures (although they tend to be expensive) or select a fixed-focal-length lens with an f/1.4 to f/2.0. Some of these, such as the 50mm f/1.8 lenses offered for most cameras, can be very cheap — $100 or less. But if you're able to spend a little more, you can buy 28mm, 30mm, 35mm, 50mm, or 85mm f/1.4 lenses that can shoot under very dark conditions. They'll be optimized to produce pretty good results wide open, too.

✔ **Shoot sharper.** You can often get better results with a special lens that was designed to produce sharper images rather than to do everything passably well. That 50mm f/1.8 lens you pick up for less than $100 just might be the sharpest lens you own. Or you might buy a close-up lens that's optimized for macro photography and produces especially sharp images at distances of a few inches or so.

✔ **Shoot wider.** Wide-angle lenses let you take in a broader field of view, which can be useful when there isn't room to move farther away from your subject. The lens that came with your camera probably has a field of view no wider than that of a 28mm lens on a full-frame film SLR. You can get a wider look from lenses designed to provide that extra-broad perspective with a dSLR.

✔ **Shoot farther.** Telephoto lenses let you bring distant objects that much closer to your camera, as you can see in Figure 4-2. The lens that came with your camera probably provides only a moderate telephoto effect, perhaps around 70mm, which, with a 1.5 crop factor, is the equivalent of a 105mm short telephoto on a full-frame 35mm film camera. Longer lenses are easy to find, fairly affordable, and fun to use when you want to reach out and almost touch something.

Figure 4-2: A wide-angle lens provides a broader view (top), while a telephoto lens takes you up close to your subject (bottom).

✔ **Shoot closer.** An interchangeable lens that you buy may be able to focus on subjects a lot closer to the lens, giving you valuable close-up or *macro* capabilities. Macro photography is literally a whole new world, encompassing

subjects that you couldn't capture before (such as small animals or insects), as well as new ultra-close looks at familiar objects.

Primes or Zooms

Digital SLRs can use one of two basic kinds of lenses: prime lenses and zooms. *Prime lenses* are fixed-focal-length lenses, the kind that were the mainstay of photographers years ago, before *zooms* (variable-focal-length lenses) became as sophisticated as they are today. Because prime lenses were the best, sharpest, and fastest optics available, it was even common for photographers to carry around two or three camera bodies, each with a different lens, to avoid having to swap lenses.

Today, zoom lenses are sharper, faster, and more practical for all-around use, but they still lag a bit behind their prime lens cousins. Your own lens kit will probably end up containing a few of each type, each suitable for a different kind of photography.

Pros for primes

Primes have their advantages. For example, if you shoot architecture, you might want a fast wide-angle lens to let you shoot interiors without a tripod or capture images from unusual angles with less lens distortion, as shown in Figure 4-3. Sports photographers might want a similar wide-angle lens for indoor sports such as basketball, mated with a fast telephoto prime lens for night football or baseball under the lights. If you plan on shooting portraits destined for display on the wall, you'll want a sharp, short telephoto lens. Prime lenses with close-focusing capabilities are great for macro work. Wide-angle prime lenses produce results that are sharp enough to enlarge to 20 x 30 inches for display as home décor.

Figure 4-3: Wide-angle prime lenses let you capture photos from unusual angles.

The main drawbacks of using prime lenses is that you must buy a bunch of different lenses to cover a range of focal lengths — plus you must be willing to swap lenses whenever you need to shoot something that doesn't suit the lens currently mounted on the camera. Digital SLR owners can be leery of changing lenses often, especially when working in dusty environments, because of the danger of getting dust on the sensor.

Pros for zooms

There's a lot to like about zoom lenses, too. They are convenient and flexible, allowing you to shoot several different magnifications without moving, so you can frame your photo carefully and precisely right in the camera. That's important when you don't want to waste valuable pixels by cropping later in an image editor.

Zooms come in several types, which I discuss in the list that follows.

- ✔ **Wide-angle zooms** have focal lengths like 10–20mm or 12–24mm. Depending on the crop factor of your camera, these offer the equivalent of 15–30mm to 18–36mm on a full-frame film or digital camera. Because of the distorted looks that these super-wides can sometimes provide, they are often relegated to special situations that truly require an ultra-wide perspective.

- ✔ **Mid-range zooms** are more general purpose. These have ranges that start at 17–18mm and extend out to 55–70mm at the telephoto end. They're usually much less expensive than other types of zooms and may be furnished with your camera at an incremental cost of only $100 or so above the cost of the camera body alone. Expect

the maximum aperture to shift as you zoom out; such a zoom may offer an f/3.5 opening at the wide-angle end, but only f/4.5 in the telephoto range.

✔ **Short telephoto to telephoto zooms** sacrifice the wide-angle end of the range to give you a telephoto reach that may extend to 200mm or 300mm. Several popular lenses go from 28mm to 200 or 300mm. The affordable models suffer from the same limited maximum aperture as the mid-range zooms.

✔ **Telephoto zoom lenses** cover only a telephoto range and tend to extend to much longer focal lengths. One of my favorite lenses is a 170–500mm zoom (although the same vendor also offers a very good 50–500mm version that is highly prized but much more expensive). Other popular telephoto zooms have ranges like 200–400mm. As with all very long lenses, you'd be crazy to use one of these without a tripod or other sturdy support. (See Chapter 2 for more on tripods.)

✔ **Macro zooms** are a specialized kind of zoom lens, usually in the medium telephoto range (from about 100mm–200mm), that can focus especially close. You'll find these lenses useful outdoors for shooting small animals and insects that must be photographed from a few feet away but that require extra-close focusing. As your critter flits or hops around, you can follow him with your macro zoom while still remaining far enough away to keep him from becoming skittish. The same lens will work with non-moving objects like flowers, too.

Special Features

Some lenses have special features that let them do things that other types of lenses cannot do. Here's a summary of some of those capabilities that are common (or uncommon) among add-on lenses:

✔ **Image stabilization:** Referred to variously as *image stabilization* (by Canon and some other vendors . . . and me), *vibration reduction* (by Nikon and allied companies), *anti-shake* (Sony), *optical image stabilization* (Sigma), and other names, this feature operates by shifting lens elements or the sensor itself to nullify the shakiness that can result when the camera or photographer wobbles during exposure. Image stabilization can give you the equivalent of two to three shutter speed increments more steadiness, so you can shoot at 1/30 of a second instead of 1/250 of a second — or with a long telephoto, 1/250 of a second instead of 1/2000 of a second.

You'll find image stabilization in the lens only (with Nikon and Canon products), or included in the camera body (with all other vendors offering the feature). The advantage of in-lens stabilization is that it can be optimized for the particular lens. In-body stabilization is nice because it transforms every lens you own into an anti-shake component.

Image stabilization does *not* counteract a moving subject and may actually slow down your camera a little when shooting sports. You'll still need a fast shutter speed for that kind of work.

✔ **Perspective control:** These highly specialized and expensive lenses shift the lens elements from side to side and up and down to improve the perspective when photographing buildings or other subjects that converge in the distance, reducing that falling backward look that you see in the top image in Figure 4-4.

Figure 4-4: Perspective control lenses compensate for distortion from tilting the camera up to take in the top of a building.

✔ **Close focus:** I've already described the close
 focusing capabilities of macro lenses. These
 lenses also offer improved sharpness and may
 include extra-small apertures (such as f/32 or
 f/45) to give you extra depth of field.

✔ **Focus control:** Some very specialized lenses
 lend themselves to portrait work by letting you
 adjust how the out-of-focus background appears
 in photographs in which single subjects are cen-
 tered in the frame, such as portraits. The effects
 you get with focus control lenses are unlike
 those available with any other type of lens.

Chapter 5

Top Ten Maintenance and Emergency Care Tips

● ●

In This Chapter

▶ Keeping fresh batteries at the ready

▶ Erasing images properly

▶ Protecting your memory card

▶ Safeguarding your camera from heat, cold, and water

▶ Backing up regularly

▶ Taking care of your computer's hard drive

● ●

*T*he old Boy Scout motto, "Be prepared," applies in spades when it comes to digital photography. Although you can't foresee all potential incidents that might snag your photo shoot, you can keep your camera in tip-top condition and practice some basic preventative measures to ensure that your equipment stays safe and in good working order. This chapter provides ten strategies to help you do just that.

Keep Spare Batteries On-Hand

Digital cameras are hungry for power, which means you will have to replace or recharge the batteries from time to time. To avoid missing important photographic opportunities, always keep a spare set of batteries or an extra rechargeable on-hand. That way you don't waste precious time running to the store or waiting for your battery to recharge when you could be taking pictures. The same holds true for an external flash, if your camera supports one.

The amount of time and number of photos that you can shoot before replacing your batteries vary depending on how you use your camera. If you start to run low on battery power, try these energy-conservation tips:

✔ **Limit the use of the monitor.** The monitor is one of the biggest power drains, so wait to review your pictures until you have fresh batteries. When you're not using the monitor to take pictures, turn it off, even if you leave the camera itself powered up.

✔ **Turn on your camera's auto-off function.** Most cameras offer a feature that automatically shuts the camera off after a period of inactivity to save power. You may even be able to reduce the wait time that must pass before the shutdown occurs.

✔ **Go flash-free.** The internal flash also consumes lots of battery juice. When the flash recycle time starts to slow down, that's a clue that your batteries are fading.

✔ **Turn off image stabilization.** On some cameras, turning off this feature saves battery power (but check your manual because this tip doesn't apply to all models of cameras and lenses).

✔ **Avoid using continuous autofocus, if your camera offers it.** In this mode, the camera continuously adjusts focus from the time you press the shutter button halfway until the time you actually take the picture. And because the autofocus motor consumes power, you can preserve some battery life by sticking with regular autofocus or, on a dSLR, shifting to manual focus.

✔ **Keep spare batteries warm.** Batteries deplete faster when they get cold, so tuck your extra batteries in a shirt pocket or find some other way to keep the chill off.

Always do whatever you can to protect spare, loose batteries from short-circuiting as well. That means protecting the metal electrical contacts from connecting (both touching the same piece of aluminum foil, for example). Most batteries come with little caps that cover the contacts, and it's a good idea to use them; otherwise, cover them with tape or keep them in separate containers.

Format Your Memory Cards

After you download images from a memory card, always *format* the card when you put it back into your camera. Also format new cards when you put them into your camera for the first time.

You typically can find a Format or Format Memory Card option somewhere on your camera's setup menus. (Don't confuse this option with the one that enables you to set the picture's *file format,* usually JPEG or Camera Raw.)

Formatting your card does two things:

- ✔ It ensures you've gotten rid of the previous files on the card.
- ✔ It ensures your card is correctly configured for your camera.

If you simply erase pictures from your card, you're essentially leaving cookie crumbs behind. (Techies call these *fragments.*) When enough fragments are left behind, they eat up space on your card and can make some cards unusable.

Keep these additional do's and don'ts in mind, too:

- ✔ If you're using an image-editing program to automatically transfer files from your card to your computer, *don't* select any option that lets you delete your files on the card as you transfer them. This is simply asking for trouble; wait until you're sure the files transferred successfully before you think about wiping the originals from the card.
- ✔ *Don't* delete images on your card from your computer; doing so can cause problems when you go to use the card in the camera again.
- ✔ Before formatting your card, *do* make absolutely sure you've downloaded all the pictures that you want to keep before pushing the OK button. And remember that formatting wipes out all files on the card, not just picture files — so if you use your card to store other things, such as music files, beware.

If you accidentally format a card that contained images that you didn't want to delete, don't despair yet: A variety of image-recovery software

programs can usually recover many lost pictures — especially if you haven't photographed more images on the newly formatted card. Most Web sites for popular memory card brands (www. lexar.com and www.sandisk.com, among others) offer various types of image recovery software programs you can purchase and download should disaster strike.

Keep Your Memory Cards Clean

If any dirt gets onto the copper strips or holes in your memory card, you may not be able to transfer images, or your images may become corrupt during transfer. The key to preventing this from happening is to keep cards as clean as possible. You can store them in your camera, the little plastic cases they shipped in, or a memory card case.

While memory cards are remarkably durable (there are stories of them going through the washing machine and still working), they're still somewhat fragile and very easily lost. CompactFlash pinholes are especially susceptible to things like lint in your pocket. (On a side note: Be careful to insert CompactFlash cards gently and in the right direction; they connect to little pins inside your camera and card reader, and you can easily bend those pins if you're too forceful.)

Lastly, try not to expose memory cards to extreme cold or heat. Setting one on your dashboard on a sunny day, for example, is asking for trouble.

Clean the Lens and LCD with Care

Is there anything more annoying than a dirty lens? Let's face it: Fingerprints, rain drops, and dust happen, and they all get in the way of the perfect image. And LCD monitors also can get gunked up pretty easily.

To clean your lens and LCD, stick with these tools:

- ✔ A microfiber cloth (like the ones used for cleaning eyeglasses). It works either with or without lens-cleaning fluid. And yes, you can go ahead and breathe onto the glass or plastic LCD to fog it up with some moisture first.

- ✔ Any cotton product, such as a t-shirt or dishtowel, is usually okay as long as it's clean and lint-free.

- ✔ A manually operated bulb blower commonly available in any camera store. Some come with a little natural-fiber brush, which is also okay. It's a good idea to use this type of tool before wiping your lens if it's especially dirty to ensure that bigger particles of dirt aren't rubbed into the lens.

Do not use any of the following to clean a lens or LCD:

- ✔ The same microfiber cloth you use for your glasses. It may have oily residue from your face.

- ✔ Facial tissue, newspaper, napkins, or toilet paper. These are made from wood products and can scratch glass and plastic and can harm a lens coating.

- ✔ Household cleaning products (window cleaner, detergent, toothpaste, and the like).

✔ Compressed air. These cans contain a chemical propellant that can coat your lens or LCD with a permanent residue. Even more scary, compressed air can actually crack the monitor.

✔ Synthetic materials (like polyester). They usually don't clean well, anyway.

✔ Any cloth that's dirty or that's been washed with a fabric softener.

 If you're using interchangeable lenses on a dSLR camera, you can attach a clear protective filter on the lens — look for something called a *UV/Haze* filter (the UV stands for *ultraviolet*). You can also buy these filters for some point-and-shoot models.

Of course, you should always carry and store your camera in a quality case or bag; see Chapter 2 for a look at some options.

Update Your Firmware

Just when you thought software and hardware were confusing enough, along comes another techno-term to deal with: *firmware*. This special software lives permanently on your camera, telling it how to operate and function — in essence, it's your camera's gray matter.

Every now and then, camera manufacturers update firmware to fix problems and bugs, enhance features, and generally do housekeeping that makes your camera operate better. Sometimes these changes are minor, but occasionally they fix pretty serious problems and errors.

To benefit from these updates, you have to download the new firmware files from your camera manufacturer's Web site and install them on your camera. If you signed up for manufacturer e-mail updates when you registered your camera (you *did* do that, right?), the company should inform you of updates when they occur. But it's a good idea to also simply check the manufacturer's camera support page every three months or so to make sure that you don't miss an important firmware update.

Depending on the camera brand and model, you typically can update your camera one of two ways:

 ✔ **Download and install the files from a memory card:** Put a memory card in a card reader connected to your computer and then download the firmware files from the Web site to the card. After the files are on the card, put it in your camera and follow the directions in your camera manual (or on the Web site) to install the firmware.

 ✔ **Download and install directly to your camera:** You also may be able to download directly to your camera by connecting the camera to your computer using a USB cable. Again, check your camera manual for specifics on this process.

Don't push any buttons or disconnect the camera until the update is finished. Cameras don't like being interrupted during brain surgery. (Be sure your camera batteries are fully charged before you begin, too.)

Protect Your Camera from Temperature Extremes

Extreme cold can cause various mechanical functions in your camera to freeze; it can stop your lens from zooming or your shutter release button from operating. Your LCD may stop functioning as well, and your battery power may drop so much that your camera won't even turn on.

If you must take your camera into the cold, keep it in a camera case under your jacket until you're ready to use it. In the photo shown in Figure 5-1 — taken while on a snowmobile safari in the Arctic region of northern Finland at –42° Fahrenheit — you can just see the camera case beneath the jacket, for example.

Figure 5-1: Extreme cold can be especially bad for your camera, and you need to protect it from the elements.

On the flip side of the temperature scale, extreme heat can damage your camera as well and can be especially hard on your LCD screen, which can "go dark" if it gets too hot. If this happens, simply get your camera to a cooler place. Typically, it will return to a normal viewing state. Although heat generally doesn't cause as many problems as cold, leaving your camera in direct sunlight (such as in a car) isn't a good idea. If you can at least cover it with a towel or t-shirt, your camera will be happier.

 Changing temperature extremes, such as going from a warm room into sub-freezing weather, are especially bad for your camera. Condensation forms on the camera parts and lens elements, which can (at best) obstruct your ability to take good photos and (at worst) cause permanent moisture damage. To avoid problems, store your camera in a sealed Ziploc-type bag until it adjusts to the new temperature.

Keep Your Camera Away from Water

Digital cameras, like most other electronic devices, don't do well if they get wet. Water — especially salt water — can short important camera circuitry and corrode metal parts. A few raindrops probably won't cause any big problems, but exposure to enough water, even momentarily, can result in a death sentence for a camera.

Did you leave your camera on the picnic table during a brief downpour? Did you drop it into the fountain? If you think your camera is potentially damaged, but not enough that it's clearly beyond hope, the following steps may help you salvage it:

1. **Remove the batteries and memory card.**

2. **Wipe the camera with a clean, dry cloth.**

 Try not to push any buttons.

3. **Set it in a warm place where it can dry out as much and as quickly as possible.**

4. **Get your camera to a good-quality, authorized repair facility or send it to the manufacturer.**

While these steps aren't a guarantee that your camera will make it, sometimes you can get lucky.

Obviously, preventing your camera from getting wet is always preferable to having it repaired, and keeping it in a water-resistant or waterproof case is the best way to avoid getting it wet. Most camera bags are at least moderately water resistant, and some even have completely sealed, waterproof compartments. Barring that, put your camera in a large, locking, plastic sandwich bag (or two).

 If you want to try underwater photography, you can buy waterproof housings that are designed to let you operate all the camera's buttons and such but still keep the innards safe and dry. Some companies also make a variety of products that protect your gear when you shoot in the rain. See Chapter 2 for an introduction to just some protection options.

Clean the Image Sensor

The *image sensor* is the part of your camera that absorbs light and converts it into a digital image. If dust, hair, or dirt gets on the sensor, it can show up as small spots on your photos. For example, you can see two spots in Figure 5-2, in the sky to the right of the pyramid. (Image-sensor spots are often most visible in the sky or in bright, clear areas of your image, but can be seen just about anywhere.)

Figure 5-2: Spots on a dSLR's image sensor appear in the same place on multiple images.

Serge Timacheff

Many new cameras have an internal cleaning system designed to remove any stray flotsam and jetsam from the sensor. Usually, the camera is set up at the factory to go through a cleaning cycle each time you turn the camera on, off, or both. You may also be able to initiate a cleaning cycle at other times through a menu option.

If the camera's internal cleaning mechanisms don't do the trick, you need to take your camera to a repair shop to have the sensor cleaned manually. Although you can find products designed to help you do this job yourself, you do so at your own peril. This job is a delicate one, and really should be done only by a trained technician. Call your local camera store to find out the best place in town to have the cleaning done. (Some camera stores offer free cleaning for cameras purchased from them.)

 You can help limit the amount of dust and dirt that finds its way to your image sensor by keeping the camera stored in a case or camera bag when not in use and being cautious when shooting in dicey environmental situations — windy days on the beach, for example. If you own a dSLR, be especially careful when changing lenses, because that's a prime occasion for dirt to sneak into the camera. Also try to point the camera slightly downward when you attach the lens; doing so can help prevent dust from being sucked into the camera by gravity.

Back Up Your Images Regularly

When disasters such as fires or floods occur, photos are one of the first things people try to save. Photographs are precious memories and often can't be replaced.

Digital images can be destroyed not only by fire or flood, but also by a hard-drive failure if that's the only place you have them stored. While not extremely common, hard drives have been known, on occasion, to simply stop working. It's difficult and expensive — and occasionally impossible — to retrieve files from one that's gone bad.

The key to preventing a disaster such as this is simple: Back up your images on a CD or DVD. Store the disks in a location separate from your originals. Some people keep backups in safe-deposit boxes at banks, in other family members' homes, or in their offices, for example.

For the complete story on image backup, including information about storage devices designed to hold your favorite photos, see Chapter 2.

Clean Out Your Computer's Hard Drive

You probably know that computers need lots of RAM *(random-access memory)* in order to run smoothly and quickly. But you may not know that a computer also needs a significant amount of empty space on its hard drive — that's the component that holds all your files and programs — to perform well. The computer uses that free space, sometimes called *scratch disk space*, to temporarily store data as it's processing your files. Without enough free space, the computer slows down and may not be able to perform some photo-editing tasks at all, especially on large image files.

Generally speaking, you should keep at least 10GB (gigabytes) of free space on your hard drive, although some photo programs may request even more. Keeping that free space available may mean moving data files onto external hard drives, CDs, or DVDs for storage; it may also mean uninstalling unused applications.

Chapter 2 gives you a look at some of your storage options.